As We Rise

As We Rise

Photography from the Black Atlantic

Selections from
the Wedge Collection

Preface by Teju Cole
Introduction by Mark Sealy
Interview by Liz Ikiriko

With Texts by
Isolde Brielmaier
Sandrine Colard
Letticia Cosbert Miller
Julie Crooks
Daisy Desrosiers
Liz Ikiriko
O'Neil Lawrence
Kenneth Montague
Ugochukwu-Smooth C. Nzewi
Teka Selman
Zoé Whitley
Deborah Willis

aperture

Throughout this book, captioning addresses images left to right across the page spread.

12 Community

80 Identity

134 Power

Letter to a Friend

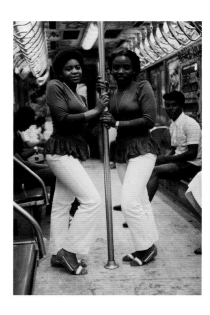

One only has to listen to photographs, dear Ken. In looking at your album, I feel this invitation to listen, and already I hear something: the word *album*. No, *As We Rise* has not officially been described as a photo album. After all, that is a term that normally carries connotations of domesticity and privacy, and this is a published book, intended to be seen by the public. An album is usually centered around a family and is a record of their intimate history, their kinship, and the passing of the years. And though *As We Rise* is full of people, we can't assume that they're all members of the same family. So why is this—*album*—the word I have heard the pictures whisper?

We share an interest in contemporary photography, Ken, and so when I look at these pictures, I recognize many of them: these are masterpieces of contemporary photography. When I visited you in Toronto a few years ago, I saw how you cohabited with these pictures, how they lined the walls of your hallways and rooms. I told you back then that it must be marvelous to live with such a focused and impressive collection. But now that the pictures have been brought together in book form, their collective juxtaposition is even more immediate: unmediated by mats, glass, or frames. Perhaps it is this that, in the first instance, gives them the aspect of an album.

But another album-like quality of the images in *As We Rise* comes from the fact of your collector's eye. Regardless of the individual photographers, the collection shows very strikingly the undercurrent that interconnects many different practitioners from many different eras and countries. It confirms for us truths we must, on some level, have known before, but have perhaps never put into words. *As We Rise* shows us what Gordon Parks has in common with Nontsikelelo Veleko; it proposes that Seydou Keïta and James Van Der Zee are brothers. In the vast majority of these pictures, we see people who are looking at the camera, at the photographer, generally at their ease, dressed as they wish to be. The portraits are highly intentional, in the sense that both the photographer and the sitter are ready for the photograph to be made, in the sense that consent is explicit or implied; and yet they are not formal or rigid, not even the ones made in a studio. And it is perhaps this feeling of ease, above all, that makes us think, *These are family pictures. This is a family album.*

Some of the photos did begin life in just this familial way, and only later underwent the evolution that brought them to the status of art. In

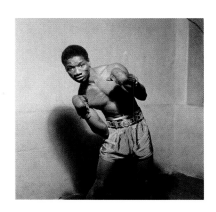

the pictures by Lebohang Kganye, for instance, we see what looks like the use of double exposure. Kganye began with a series of amateur photographs of her late mother, to which she digitally added herself wearing the same dresses and clothing her mother wore. The result is a series of mother-daughter portraits of a kind never seen before (pages 110–11).

As We Rise is about family, and what an enormous, confident, joyous, and stylish family this is. All through it, we also see that family has a predisposition to doubleness or twinship. It could be through a doubling like Kganye's; or it could be in the work of Rotimi Fani-Kayode, who presents his subject in two self-portraits side by side; or it could be Erika DeFreitas, who similarly presents herself in multiplicate. There is doubleness, too, in the rhyming poses of Jamel Shabazz's subjects. And there is literal doubling of the twin infants in the Malian studio portraits by Seydou Keïta.

These are pictures that say: *I am not alone, I have another with me.* In so many of these photos, people are accompanied. Even, paradoxically, in the pictures of just one individual, we also sense accompaniment. Almost everyone here is in implied community. Too often in the larger culture, we see images of Black people in attitudes of despair, pain, or brutal isolation. *As We Rise* gently refuses that. It is not that people are always in an attitude of celebration—no, that would be a reverse but corresponding falsehood—but rather that they are present as human beings, credible, fully engaged in their world.

Portraiture is generally taken to be the preserve of valorized white photographers. Of course, they don't call it "white portraiture"; it is presented as universal. But it is white portraiture, as white as the all-white spaces of which they do not seem to tire. Many of us do tire of those spaces though, and when I look at the marvelous pictures you have gathered here, pictures by Deana Lawson, by Oumar Ly, by Dawoud Bey, I feel myself restored to a world that makes sense. The girl in a portrait by Liz Johnson Artur could be one of my baby cousins. The man in the boxer's pose by James Barnor could be my grandfather. Aren't those my cousins in Dawit L. Petros's pictures? The sanity I detect in these pictures is not accounted for simply by the Blackness of the subjects. It is that the world it evokes is so wide and complex, both familiar and unfamiliar, that it feels like an organic correction to what has been left uncorrected for so long.

As I said before, dear Ken, each of these artists actually has their own style and their own priorities. If we had more than one or two or a handful of photos by them, the divergences between their individual aims would be more explicit. I did a double take when I saw that you had included my photograph of a stylish young boy in Brazzaville, Congo, in this album. Suddenly, I saw how that photograph could speak to others; how, when removed from my project *Blind Spot* and brought into the project *As We Rise*, its valence shifted and was positively altered.

What you've done here, with the help of Liz and the wonderful team at Aperture, is like one of those marvelous house parties that are popular throughout our Black Atlantic. You have created a scene, a mood, a lovers rock. This is hospitality. Like a gifted selector, you have delivered one excellent track after another. The album—and now I mean it in both its visual and musical senses—is an unforgettable groove, and I love it.

Jamel Shabazz
*Best Friends,
Brooklyn, New York,* 1981
(Left)

James Barnor
*Ginger Nyarku,
Featherweight Boxer with
Coronation Belt, Accra,* 1953
(Above)

7

A Gathering of Souls

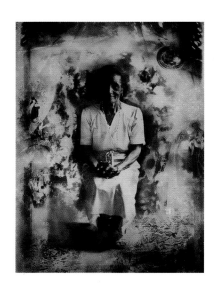

Photographs brought together from different spaces, mindsets, and cultures function as provocations dropped into the calm waters of our thoughts. They challenge our thinking, sometimes hiding the meanings buried within them, but clearly working as part of our process of trying to make sense of this world. For historically marginalized people, photographs, when presented with care, can help locate our missing chapters. Images keep people in life; when curated with dignity, they can resurrect cultures that have been denied visibility or made silent. They help us understand by holding up the making of our lives; they pause us, offering respite from the velocity of our existence. Photographs tease us with questions like, "Was I there?" or "Is that us?" "Is it real?" or "Did I witness this event or simply imagine it?" Though photographs never provide the complete answers, they might, at times, adjust or reset our sense of reality. Most important, they can help us frame new questions, uncouple and delink us from harmful dominant narratives, and allow us to feel the presence of a past moment in the now of our time.

In some of the photographs in this book—drawn from the Wedge Collection, owned and curated by Kenneth Montague—the quest for freedom and personal liberty is made exquisitely evident. Many of the collection's photographs work to revitalize a sense of joy in resistance. We sense this in a black-and-white photo, made by the Greenville, Mississippi–based studio photographer Henry Clay Anderson, of the motorcycle riders (page 33). The young African American couple oozes with pride and pleasure. Wearing the signs of rebellious youth—leather jackets and fashionable headgear—while sitting astride their powerful Harley Davidson Hydra-Glide motorcycle, the couple disrupts the stereotypical representations of African American life in 1960s Mississippi. The image is a powerful motivator for a generation of young people on the move.

As a time-trapping process, photography continuously offers us the opportunity to reflect on the way we were and make real, in the present, what we have become. It also helps us to see beyond the limits of our own experience and into new horizons, so that we can dare to imagine what we might be in the future. When photographs are produced and cared for with a community at heart, they provide a stage for their makers, subjects, and stakeholders to proclaim, "This is me, we, and therefore us."

Collecting such images together is also a form of care. The work a photograph does in culture is always complex; an image has no one decisive meaning. It shifts in time and bends to the present understanding of mind and place. When we look through the collection of photographs that Montague has built, we register both his care in bringing them together and the new meanings created in their gathering. These are pictures Montague deeply identified with and felt were missing from the official narrative, pictures he needed to see. He hews closely to his father's mantra, "lifting as we rise," in his collecting, elevating the experiences of Black lives, the artists who capture them and, in turn, viewers who identify with them. As a result of this dynamic, Montague's collection of photographs—made through the lens of the African and African diasporic experience—is a rare, insightful, radical, and bold act of deliverance. The arc of Montague's collection allows for a mosaic set of adventures to congregate and claim the right for a people to inscribe meaning to their own lives.

A photograph taken by the Jamaican-born, Birmingham-based British photographer Vanley Burke, *Boy with Flag, Winford, in Handsworth Park* (1970; page 15), immediately opens a portal back to my childhood. Like Winford Fagan—the subject of this photograph—I, too, was busy building makeshift bicycles, enjoying the freedom cycling offered. If, like Fagan, you managed to fit a pair of cow-horn handlebars to your road-eating machine, it was infinitely wider, cooler and, therefore, more desirable. In the photograph, Fagan stands with his right hand confidently resting on his hip, willingly presenting himself to Burke's caring camera. He is relaxed as his presence in the park is recorded—and not by a stranger. Burke, we learned later, was known to Fagan and his family, and to the wider Handsworth community, for his photography. It's in this obvious moment of warmth between Fagan and Burke that we can begin to unpack the undercurrents at work in this seemingly peaceful moment.

Growing up in Handsworth, Birmingham in the 1960s and '70s was, for Black people, never simply about having a quiet ride in the park. In 2015, the *Guardian* interviewed Fagan as part of a series titled *That's Me in the Picture*. In it, he recalled that at the time, "there was a lot of racial hatred and gang violence. I remember being chased by skinheads, most of them a lot older than me, but some my age. . . . At the weekend we had more time to ourselves, and you'd run into gangs who went out to attack black people." The Union Jack that Fagan attached to his bicycle was culturally and politically charged. As he informs us, "A union jack was something you would have then, not just for bunting. People asked me, 'Why not a Jamaican flag?' but I didn't know about Jamaica. I was born here. My parents came here 50 or 60 years ago; I was one of the first generations." With a greater understanding of Fagan's childhood and the social politics at work outside the frame, we can begin to understand that his presence as a Black subject in a public park flying a Union Jack marks him as being at risk, a child exposed daily to threats of racial violence. His bicycle, in the time and space of this photograph, becomes more than just an object of pleasure; it functions as a potential means of escape from those that despise his presence in Britain and his flying of the Union Flag. The photograph is powerful in that, for a brief moment, the atmosphere of hate that invisibly engulfs both Fagan and Burke becomes insignificant.

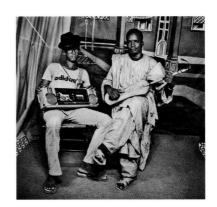

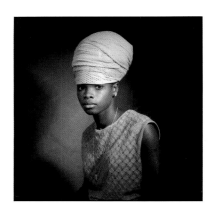

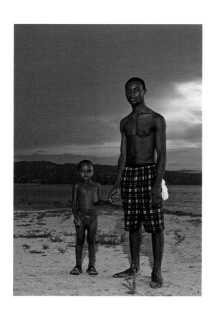

Images assist us in understanding multiple narratives of history. *Boy with Flag* celebrates, locates, and anchors the young Black British subject in history, and its radicality as an image provides us with the opportunity to see what it means to embrace and protect those who are most vulnerable in our society. The photograph also opens a portal to discussions of British imperialism's global impact and the ongoing violence this entangled legacy entails. It's forceful, playing simultaneously to the joy and pain of Fagan and Burke's shared condition.

A community can only survive when care is present, and Burke's work confirms the vital role that photography plays in the act of people caring for each other. Burke has not taken anything away from Fagan—the experience of his childhood remains intact—yet he has given his likeness new meaning in the archives of photography. Burke's camera in the park on that day in 1970 went beyond photography and memory. What Burke gave Fagan was a gift that would transcend space, time, politics, and photographs. It was the gift of self-esteem that resonated, slowly but surely, through Handsworth's Black community and beyond. Many years later, Fagan's wife would use Burke's photograph as the image on an invitation to her husband's fortieth birthday party.

Photographs are vehicles that transport us both to known and unknown places in our minds. They hold our multiple identities, and are essential keys to our cognitive world. They function as visas for our future journeys, because what we see in the past helps formulate our future. Photographs open sensory space. I have never forgotten the moment when I watched a Black mother stroke a photographic image of her deceased child while calling out his name. It was one of the few moments when photography broke me down not because of what I had seen, but because of the deep well of meaning that event extracted from me. Photographs help us connect to our lived experience's emotional terrain; they direct us to our core baselines.

Montague's photographic collection underlines the fact that Black identities are unfixable and that photography, when used as a tool for making the internal human condition visible, becomes a rich source of infinite possibilities regarding constructions of the self and those we identify with through real or imagined codes, signs, or languages. It's here that the magic of desire, different cultures, and emotional states can be brought into visibility, laid bare, demystified, or recoded.

Carrie Mae Weems taught us something extraordinary when she produced her exquisite work *Untitled (Woman and Daughter with Make Up)* (1990; page 109), in which the kitchen table's domestic space is the central stage. Here, the roller coaster of life's emotional states is served up for inquiry. Weems, through her autobiographical camera, invites us strangers to sit at her table of life; we are welcome but silent guests, unable to offer comfort, share the joy, or act in the scene. As viewers, we become voyeurs. As guests, we can only observe as the girl inherits the older woman's relationship to her own reflected image. Here we can feel, by our proximity to Weems's subjects, the invisible transference of shared culture. In this tabled episode, the two protagonists have become one, bound by what "making up to face the world" represents. As we observe the older woman and the young girl preparing themselves in their respective mirrors, we as

an audience are invited to witness a form of cross-generational gender formation performed in the most everyday domestic scenario. The mirrors on the kitchen table signify distinctive gateways to the outside world. Even though the protagonists are divided by age (time) and experience (knowledge), they both seem to understand that in the act of sharing the space of self-preparation, there is no escape from the domains of representation at work in their lives. In framing this scenario for an audience, Weems has invited us to think through the conventions of the everyday moments that make up who we are, and how representation works on us.

When brought together in a considered, congregational way, photographs can function as a magic hall of mirrors; some of their reflections appear unfamiliar, dislocating and strange, while others seem brilliantly clear, honest, humorous distortions or close friends. If each time we visit the mirror, we have changed, then the same applies to the photograph's effect on us. The unfairness of a photograph is that it stays still while we have no choice but to move on. It's in this hall of mirrors that a photograph does its best work on time and space—fueling memories, igniting the imagination, and opening up our multidimensional selves.

Photographs grip us, frighten us, and taunt us. They encourage us to turn away and not see what is often most evident and cruel in humanity. Critically though, the essential aspect of a photograph is that it helps us share and celebrate our myriad ways of becoming. When they are gathered together with a sense of heart in mind, what emerges is a fuller language of understanding how the making of our collective soul is seen. African and African diasporic photographers have played an incredible role in framing the understanding of who we are. Joy Gregory, Liz Johnson Artur, Seydou Keïta, Deana Lawson, Eustáquio Neves, and James Van Der Zee, among many others, all form part of a community of trans-African dream catchers whose images collectively and consciously work against the slow tide of negative representations that have historically engulfed the Black body.

The collection of photographs gathered here signpost a different direction of travel for the Black subject. This collection places the Black subject front-, back-, and center stage in photography—as producers and as equal subjects of inquiry. Here, the Black body is not a distant bag carrier, an emaciated victim, or a broken war-torn figure rendered only as a dead history. Here, the Black subject is a living, inspiring, loving, and aspirational subject—innovative and full of knowledge, transforming and claiming their rightful place in time. The Wedge Collection points to a place of pleasure and challenges the old discourses surrounding photography's history. Montague's gathering provides an opportunity to build new knowledge and join the dots differently, to assist in establishing a new conceptual map of the world. He has formulated a dynamic photographic treasure trove where the image of the Black subject is allowed to shine, untroubled and protected from the old imperial pirates.

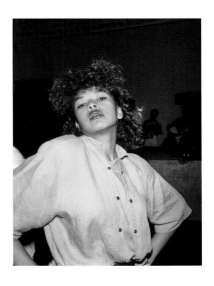

Ruddy Roye
Two Boys, 2010; from
the series *Nigga Beach*
(Left)

Afonso Pimenta
*Black Soul Dance at
the Italiana*, 1987
(Above)

In this book and collection, the term *community* functions as a locus of belonging for Black people the world over. In relation to our greater cultural context—at this particular time, when dominant systems are exposed and challenged for their oppressive machinations—community becomes a location of safety. There is a sense of seeking in photographs of Black subjects by Black photographers; a search for visual cues that, when found, have the power to present the world from a familiar, loving perspective—from within that community. Loving, joyous depictions of Blackness are radical when media are more likely to broadcast and publish denigrating depictions of Black life. Finding safe spaces becomes paramount: spaces to shed the layers of protection required to face a society that has proven, time and time again, that your simple and profound human worth is insignificant. Spaces to dance, to pray, to sing, and to share leisure time are not discretional—they are necessary. There is a deep catharsis in witnessing these joyous, sweaty, sexy, unguarded moments reflected in the photographs created in the community and collected here.

You might not recognize artist Gloria C. Swain, shown with eyes closed and hands gently clasped, pictured by artist Michèle Pearson Clarke (page 40); but like the familiarity drawn from any number of Jamel Shabazz's definitive street portraits (pages 18–23), the trust, comfort, and connection between subject and photographer cannot be denied. Acknowledging and understanding those connections emphasizes the value of being seen, and reveals the impact of intimacy and belonging.

Spirituality has long been the safest site of collective assembly and freedom dreams for Black folks. Keys to survival and progress are shared in images that are joined by faith and passed on through the generations. From Gordon Parks's image of husband and wife on their way to a Sunday church service (page 36), to Deanna Bowen's documentation of the passing down of family heirlooms (page 37), and Anique Jordan's memorial honoring the site where a Black Methodist Episcopal church once stood in the heart of Toronto (page 39)—these images are transmissions, coded messages of endurance in the community.

Presented against a profound deficiency in positive representations of the community depicted in popular culture and the contemporary art world, the pictures here forefront the experience of Black life, in all its myriad forms: a marker of the histories and spaces (real and ephemeral) that transcend geographic boundaries—from photo studios in Mali, to the nightclubs of southeastern Brazil, to the streets and subways of Manhattan. The collection extends out to a global diaspora and proclaims, "We are home."

—Liz Ikiriko

Community

Community

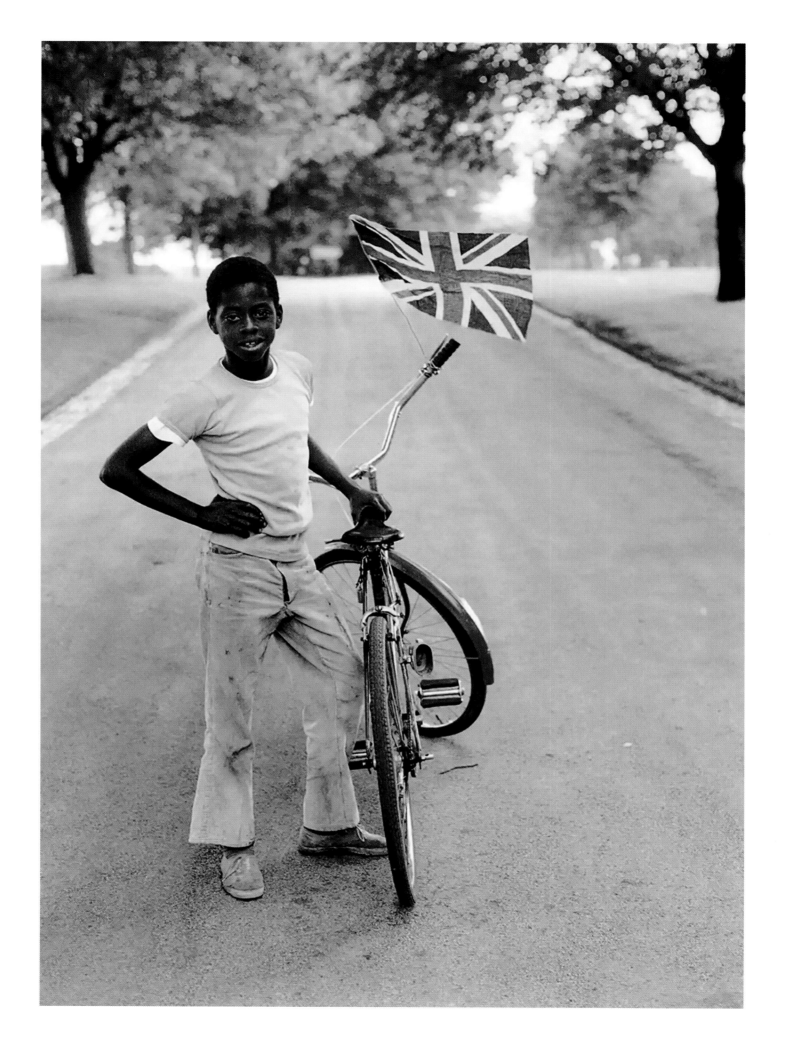

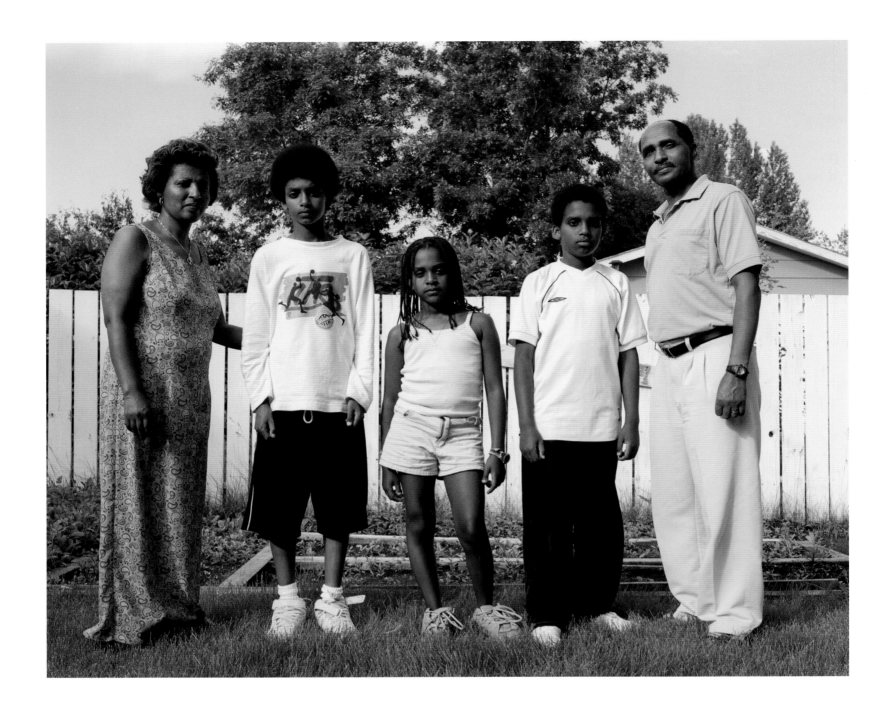

Dawit L. Petros
Hadenbes, 2005

Elias and Amal, 2004

The Porch, 2003

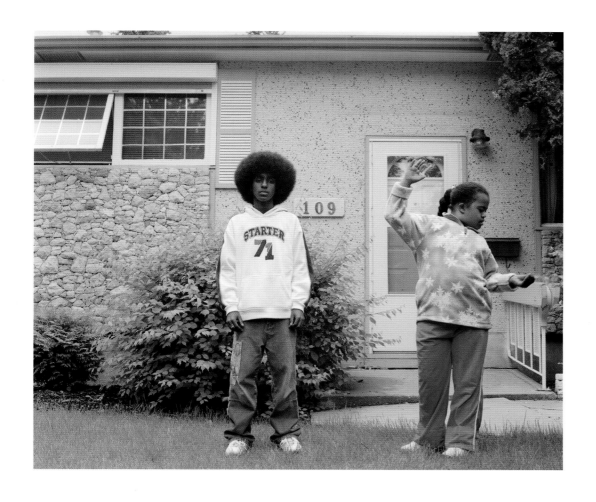

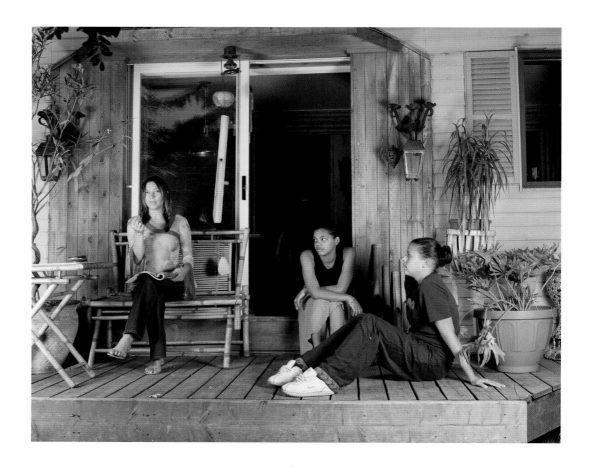

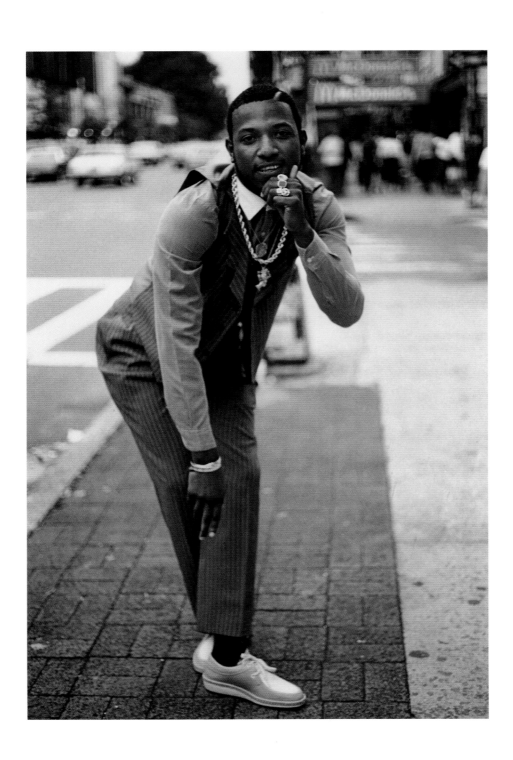

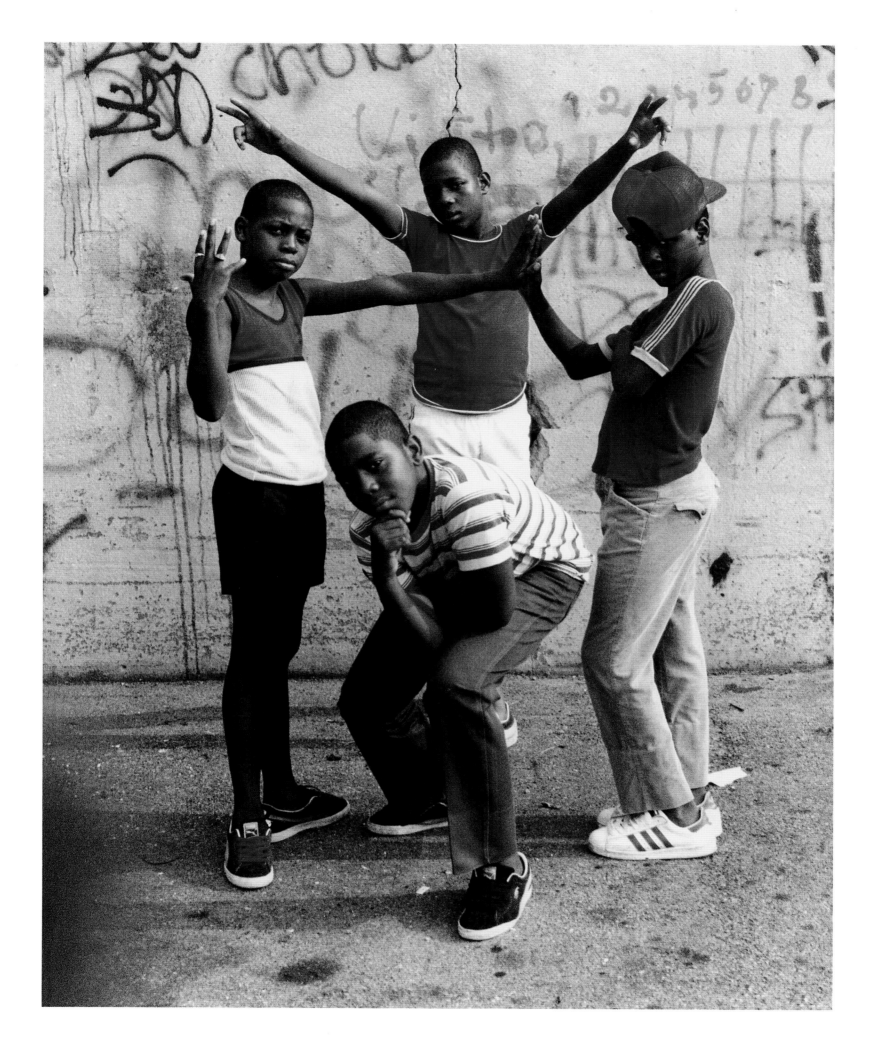

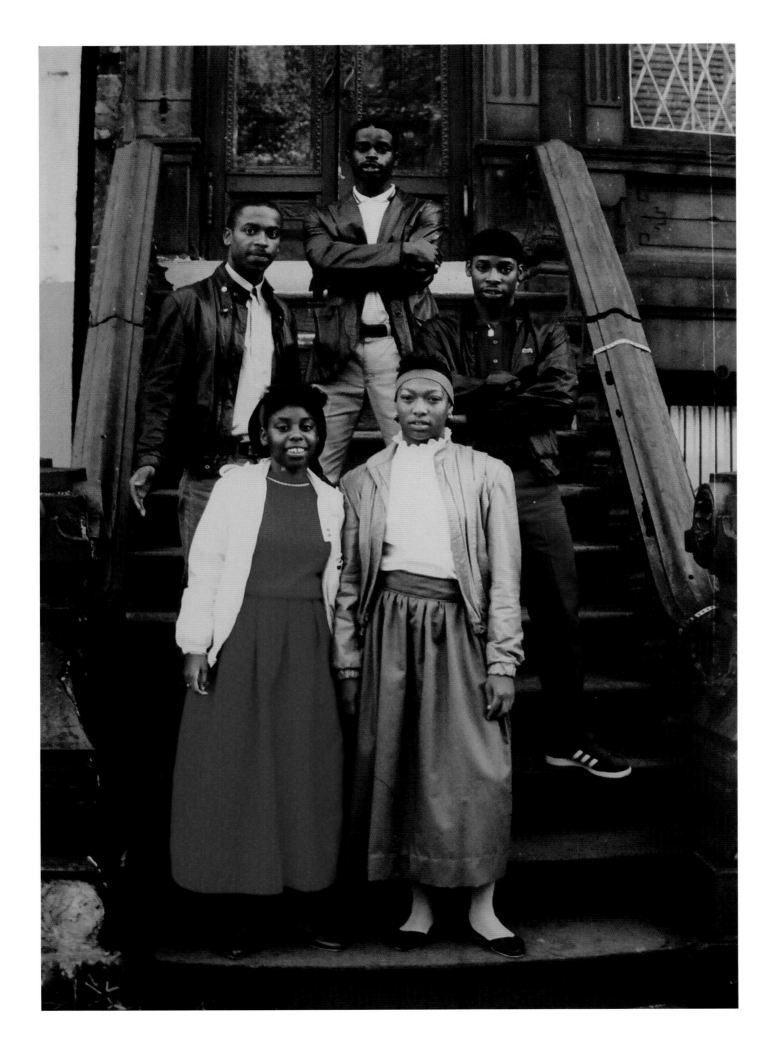

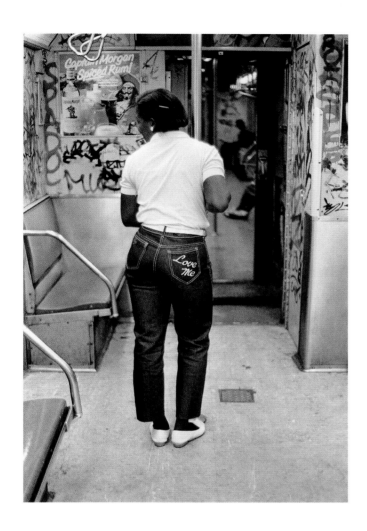

Jamel Shabazz

Back in the Days, Harlem,
New York, 1985

Love Me, Brooklyn,
New York, 1981

Rolling Partners, Brooklyn,
New York, 1982

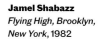

There is a palpable sense of care for the community in the photographic work of both New York City's Jamel Shabazz and Toronto's Tayo Yannick Anton.

Jamel Shabazz captures the early days of hip-hop, before it became a global industry, when it was a movement born out of the Black American experience and taking place in neighborhoods in Harlem, Queens, and Brooklyn (pages 18–23). His subjects, often groups of friends, are active participants in the pictures—proud and joyful in their self-expression. Shabazz's generosity is legendary, his approach is always genuine, and his love of community—so evident in these images from the streets of New York in the 1980s—has resulted in an essential archive, a timeless record of beauty and style.

Similarly but thirty years later, Tayo Yannick Anton, an African Canadian photographer, has spent many nights over the past decade documenting *Yes Yes Y'all*, a hip-hop party in Toronto created for queer people of color to feel represented and seen (right). The youthful energy in the images attests to his approach: anything goes. Anton's work celebrates community, diversification, and the ongoing decolonization of social events and spaces. His photographs radiate with Black joy.

—*Kenneth Montague*

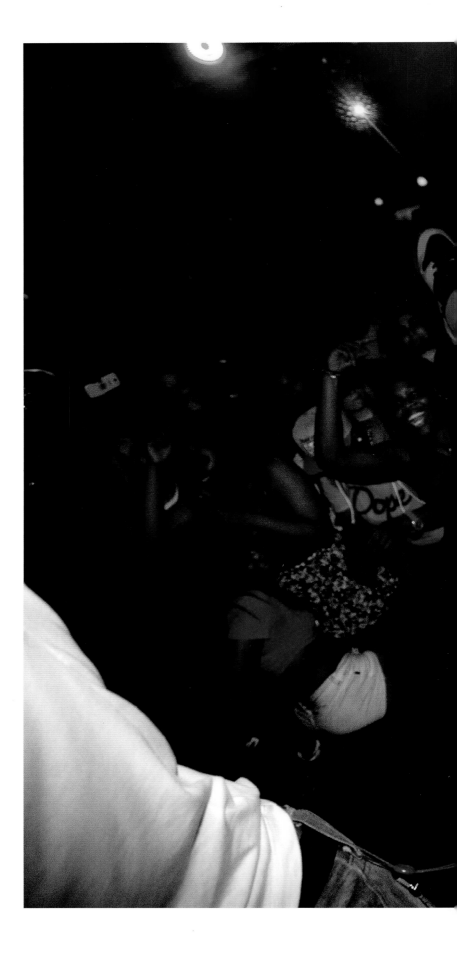

Tayo Yannick Anton
Backway, 2013

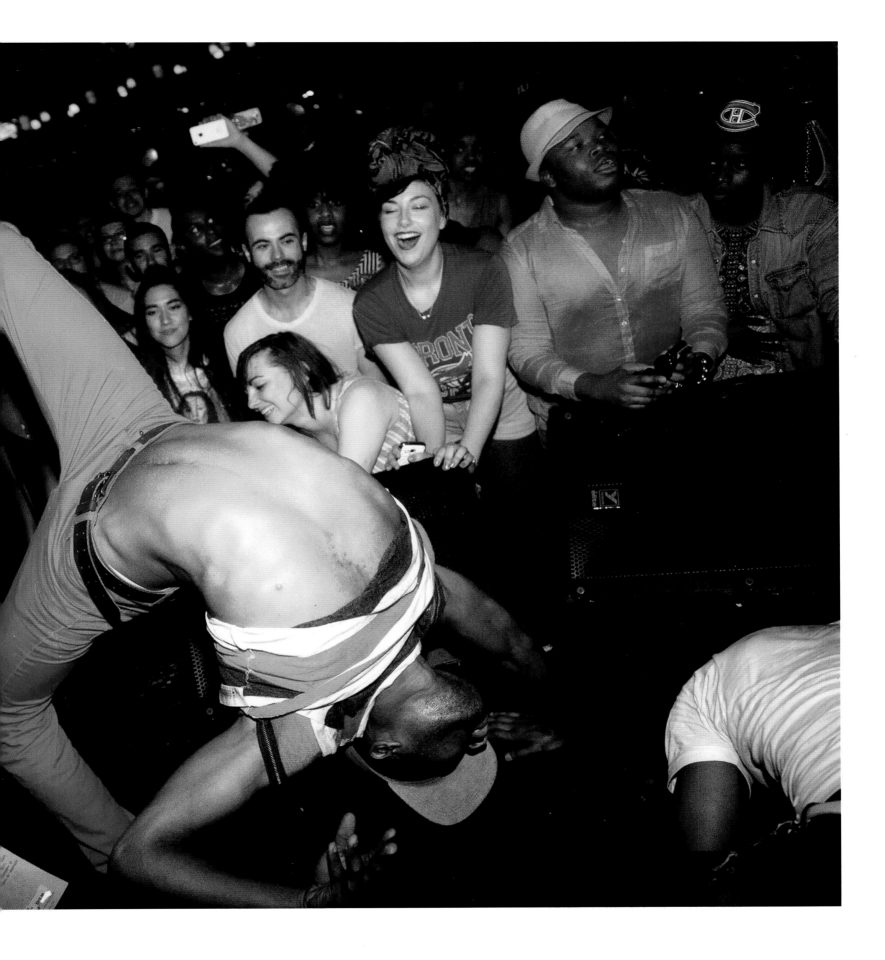

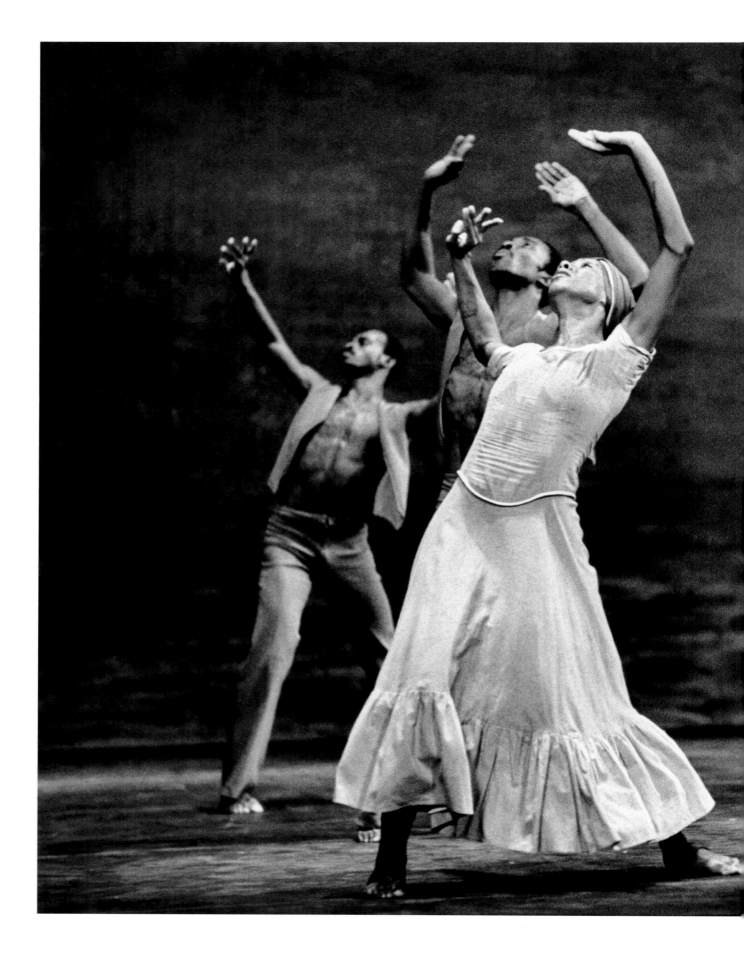

Community

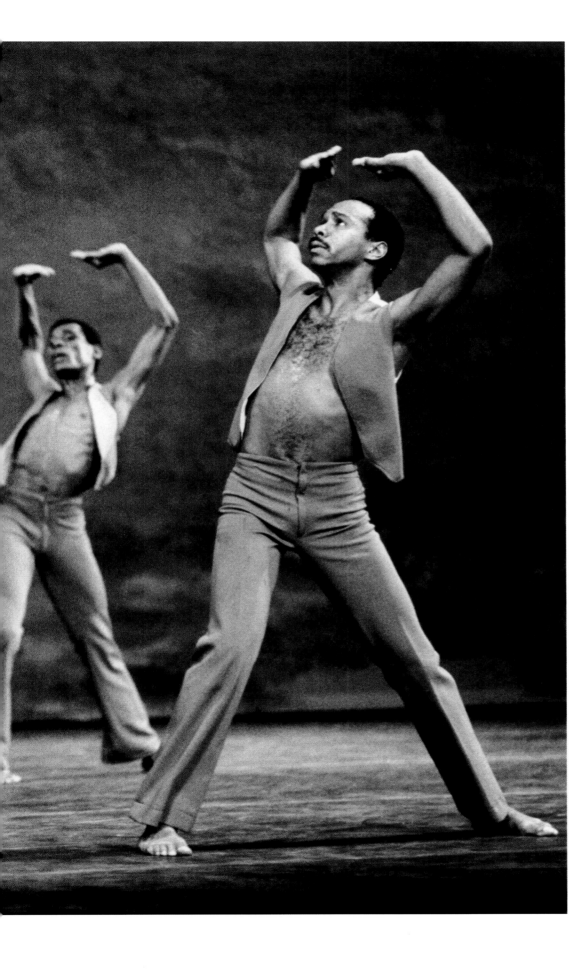

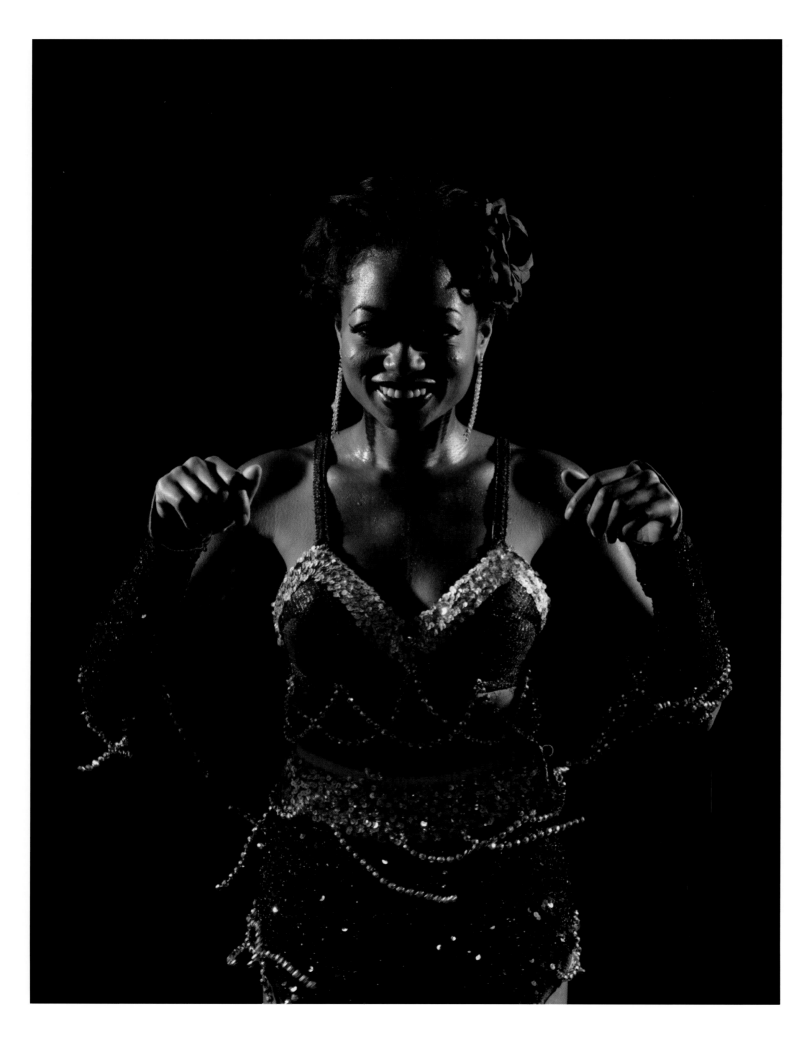

Stan Douglas
Malabar People: Dancer,
1951, 2011
(Left)

Raphael Albert
The Harder They Come,
Hammersmith Apollo,
London, 1972
(Below)

Miss Black & Beautiful
Sybil McLean with fellow
contestants, Hammersmith
Palais, London, 1972
(Right)

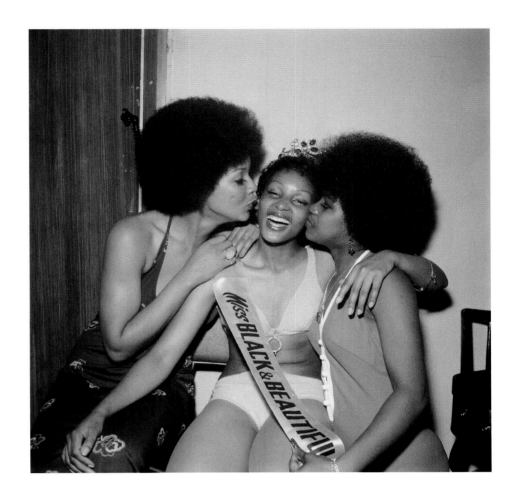

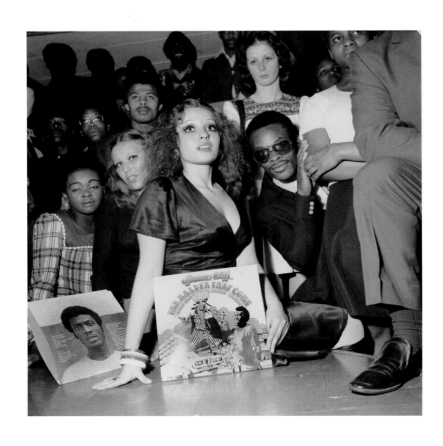

Malick Sidibé
Nuit de Noël (Happy-Club),
1963

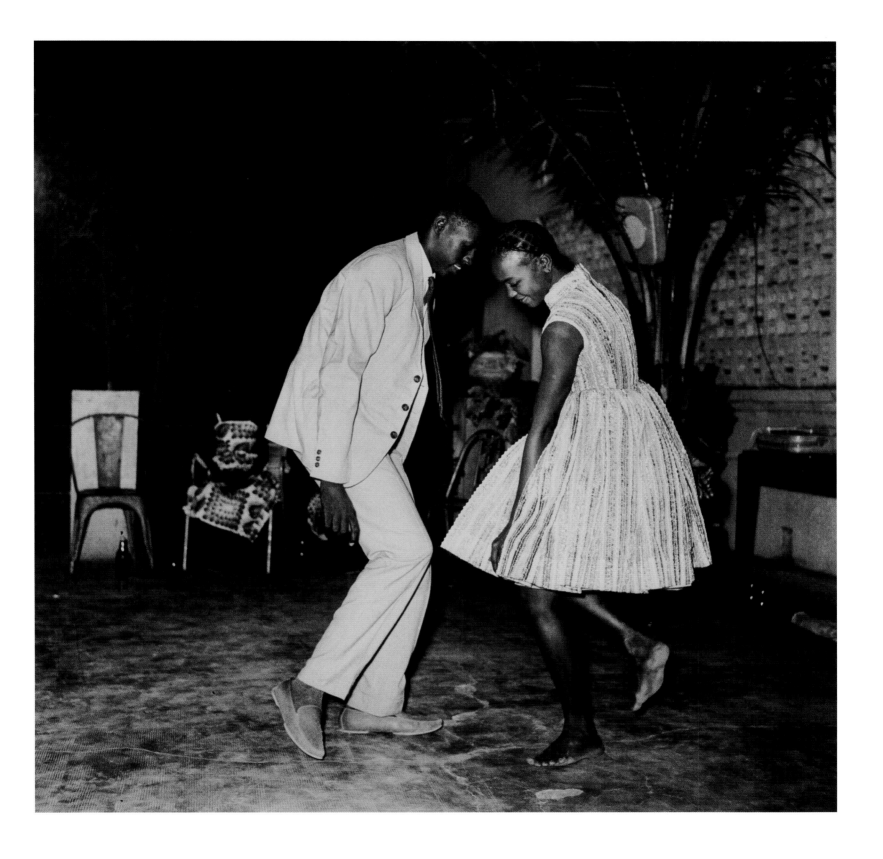

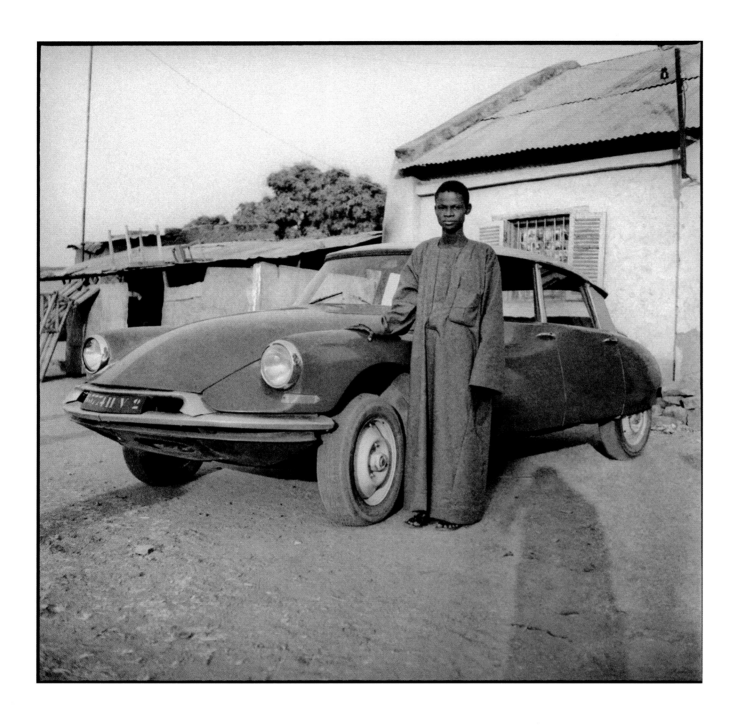

Sanlé Sory
La DS et son ombre,
ca. 1972

Henry Clay Anderson
[Portrait of a couple on
a motorcycle outside of
Anderson Photo Service
Studio], ca. 1960

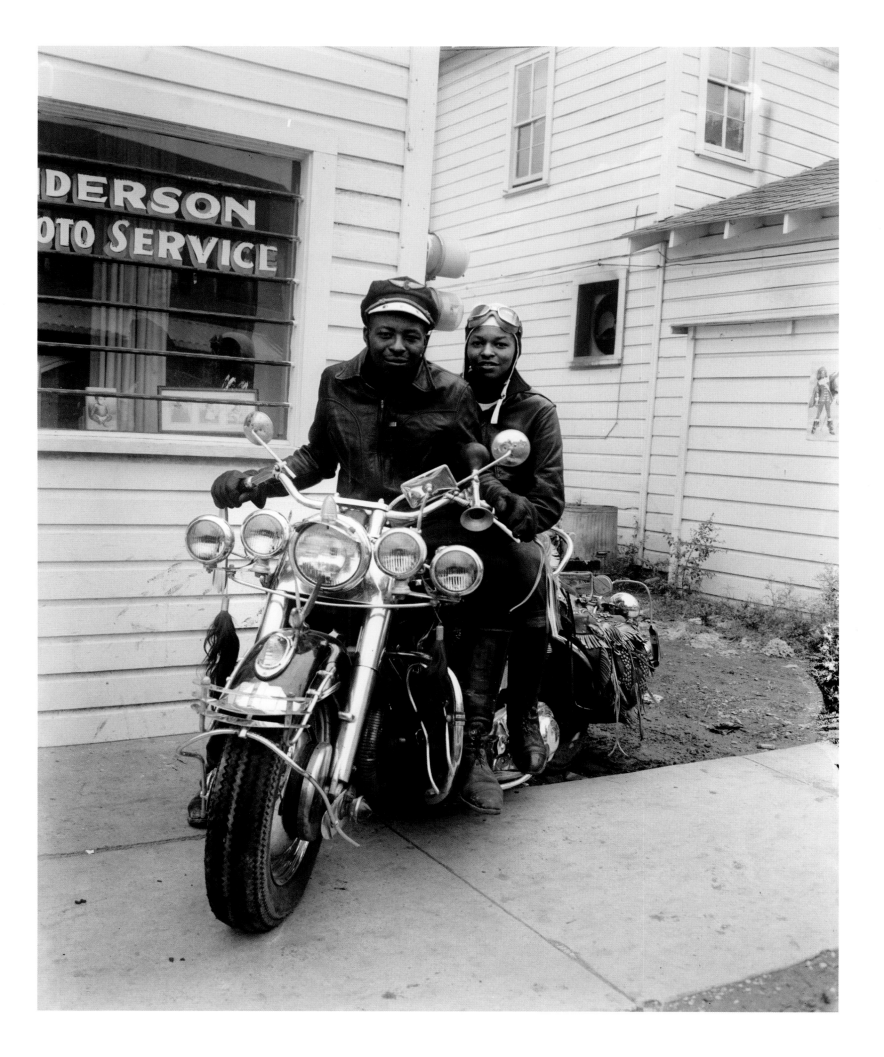

Gordon Parks
Husband and Wife, Sunday Morning, Detroit, Michigan, 1950

Deanna Bowen
Treasury of Song: (Robert H. Coleman. Dallas, Texas, 1917), 2007

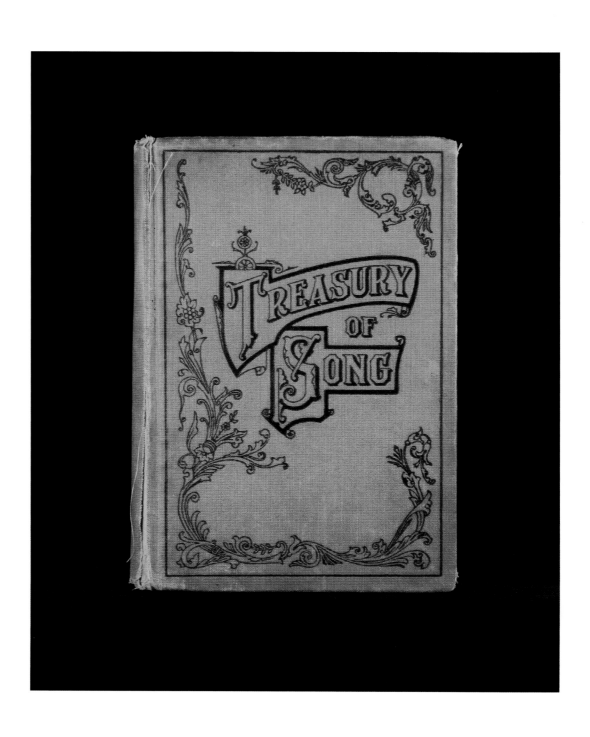

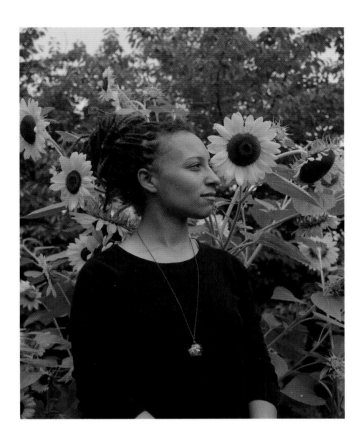

Michèle Pearson Clarke
Gloria, July 23, 2018

Melisse Sunflowers,
July 30, 2018

Oreka #1, July 25, 2018

With Leslie Hewitt's *Riffs on Real Time* series (2002–9), we are invited to explore how the acts of storytelling, remembering, and archiving can be redeployed in the making of images and objects. Found photographs are here juxtaposed with a surface that reveals the artist's take in complexifying the relationship between composition and collective memory. Informed by personal and art historical references, as well as film and photography theories, the composition can be read as an ensemble of forms that gives authority to personal narratives rendered in family photos, Black cultural and historical markers, and intimate mementos, and their potential in the context of renewed iterations.

While the artist may also be reflecting on the indexical role of the *still life*, here, its reference also addresses the production of knowledge, new meanings, and possibilities emanating from the ways we comprehend the Black experience and its public manifestations. The material nature of this work is also one that compels us viewers to glimpse into the tangible and sculptural nature of the found object itself. The traces of its usage uncover a life before this one and, in being renegotiated, it becomes a nonlinear correspondence between the historiographic, the temporal, and the mnemonic. As a whole, the work becomes a continuum. It is an expansive reflection on the conceptual possibilities of the image as both a construction and a renewed site of interpretation.
—*Daisy Desrosiers*

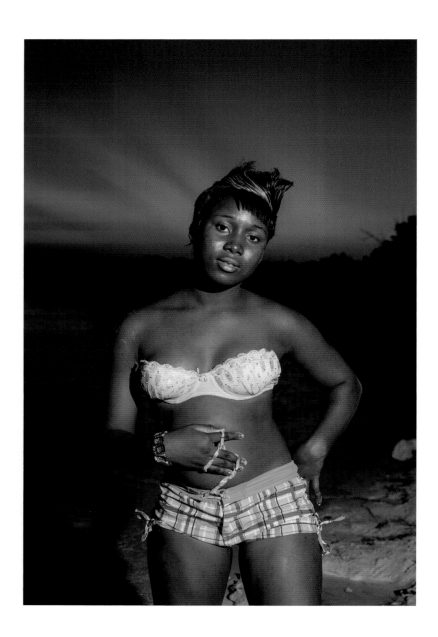

Made on an underdeveloped bit of reclaimed land in Montego Bay, Jamaica, dubbed "Nigga Beach" and "Dump Up," Jamaican-born photographer Ruddy Roye's images present a series of portraits of the city's less affluent citizens, posed formally in an environment that belies the selfie-worthy paradise experienced by tourists nearby. Roye's pictures are simultaneously documents and portraits. The dignity of his subjects is unmistakable—their self-assured attitudes as they regard the viewer, or even turn inward, are symbolic of the social contract they have entered into with the photographer. Economically excluded from the Tourist Board's paradise, they create their own space in the remnants of the artifice, with the true beauty of the island in both the fore- and backgrounds.
 —*O'Neil Lawrence*

Ruddy Roye
Nor Easter, 2011; from
the series *Nigga Beach*

The Question, 2010; from
the series *Nigga Beach*

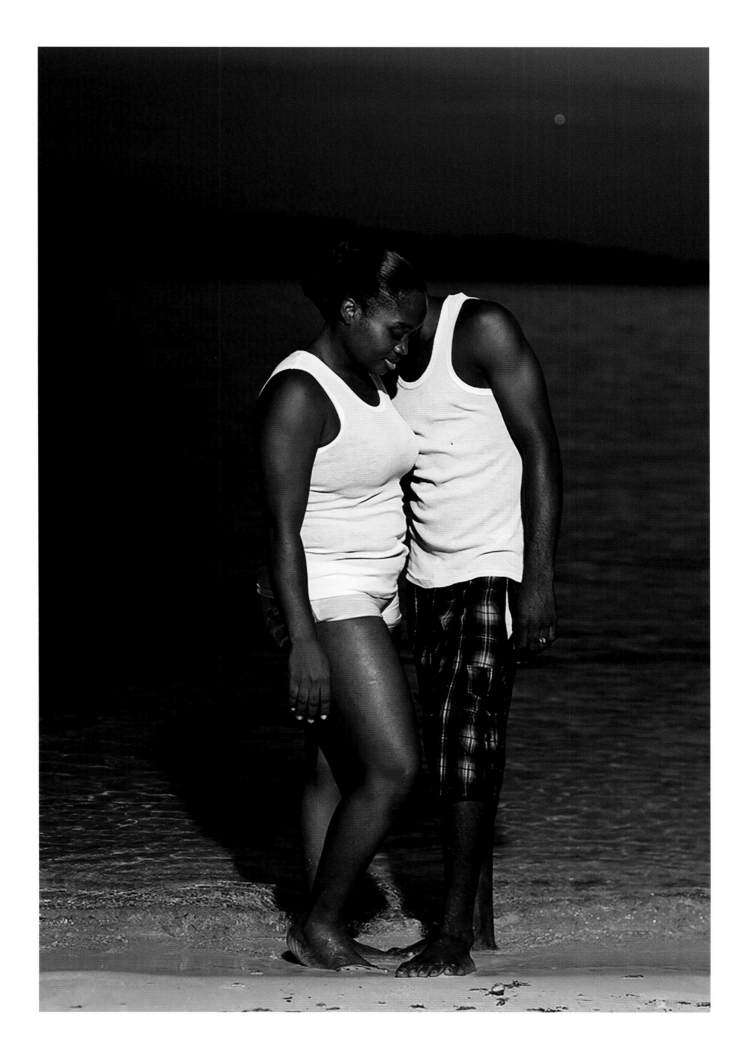

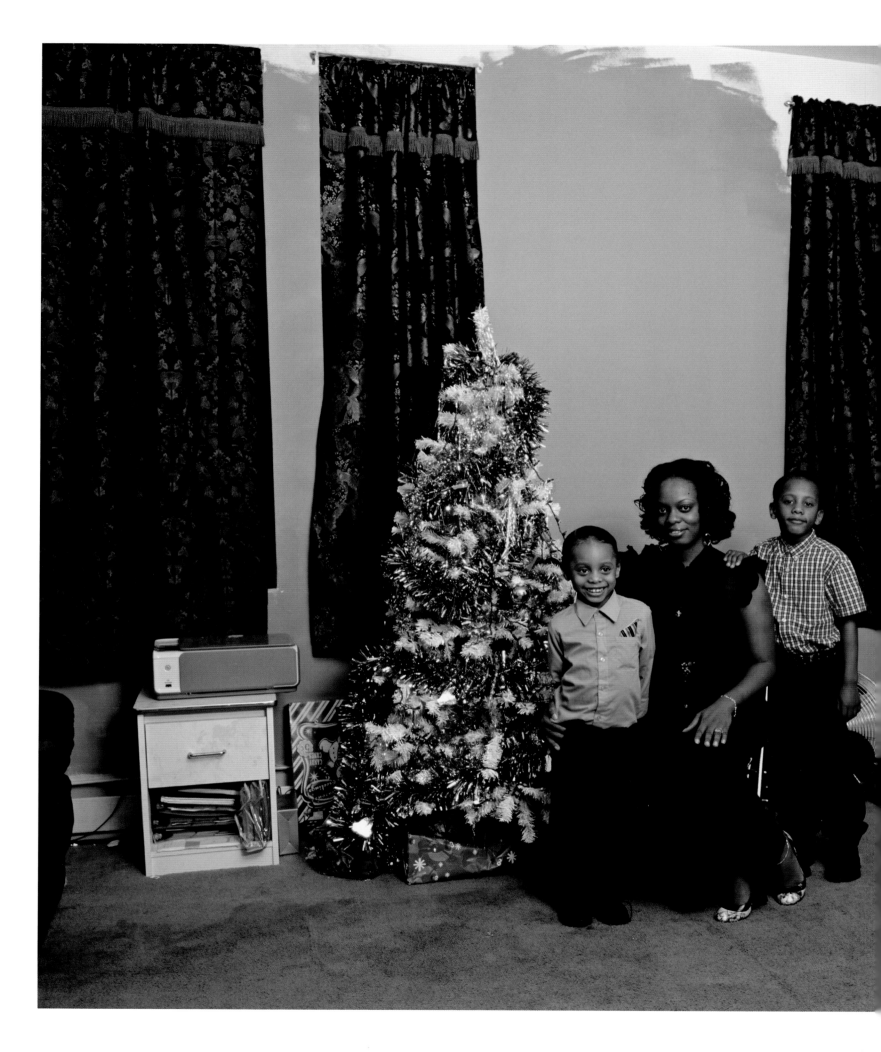

Deana Lawson approaches a photograph as a painter does a canvas, deeply considering texture, palette, and affect long before she arrives on set—sometimes the home of a stranger or, on occasion, her own bedroom—camera in hand, gear slung across her shoulders, and bags of props freshly procured from the thrift store. Born and raised in Rochester, New York, to a long line of working-class women and a family devoted to the creation of images (her father, a photographer; her mother, an administrative assistant for Kodak), Lawson's ability to capture the intimate and quotidian beauty of Black life across the Americas and Africa is innate and, as a result, profoundly generous.

Here, in the tradition of the Dutch Golden Age, Lawson constructs the quintessential family portrait at Christmas, but with a capaciousness palpable to its viewer in all that it refuses to conceal. Lawson, alongside the Coulsons, invites us to imagine the family's Christmas day, and to wonder which presents under the white tree with its gold and blue garlands will be opened first, which film from the tower of DVDs will be playing in the background as the children play with their toys. We think, too, of all that was done to make this space a home—the paint job that was never completed, the tracks left behind by the vacuum cleaner, the printer that is rarely used but has nowhere else to go. Every part of the image's composition is essential to perceiving its whole, which is, plainly, a family content in one another's embrace.
—*Letticia Cosbert Miller*

Deana Lawson
Coulson Family, 2008

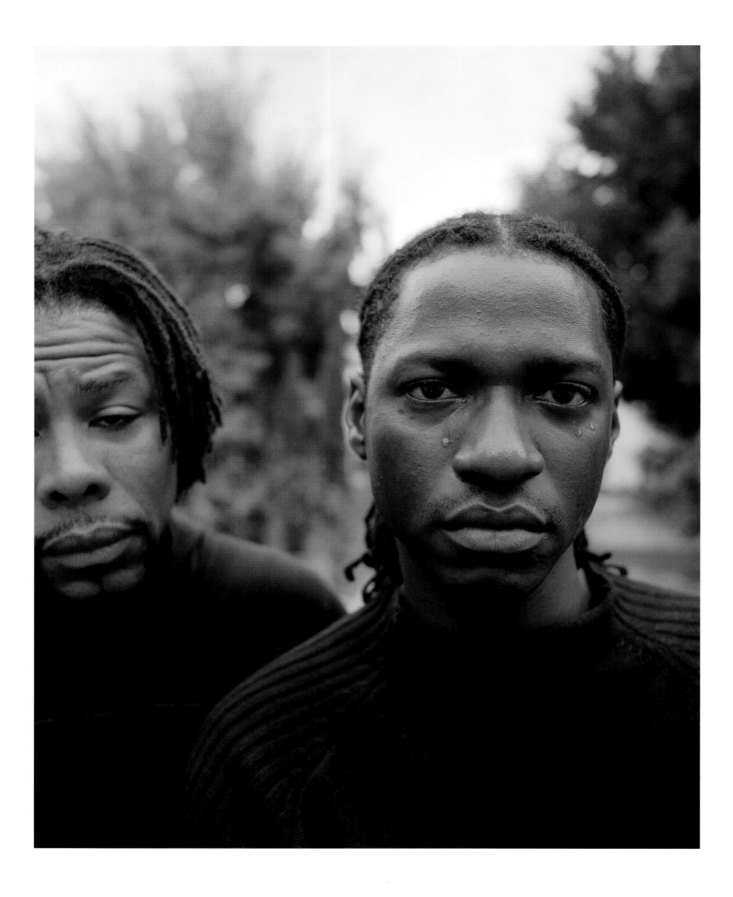

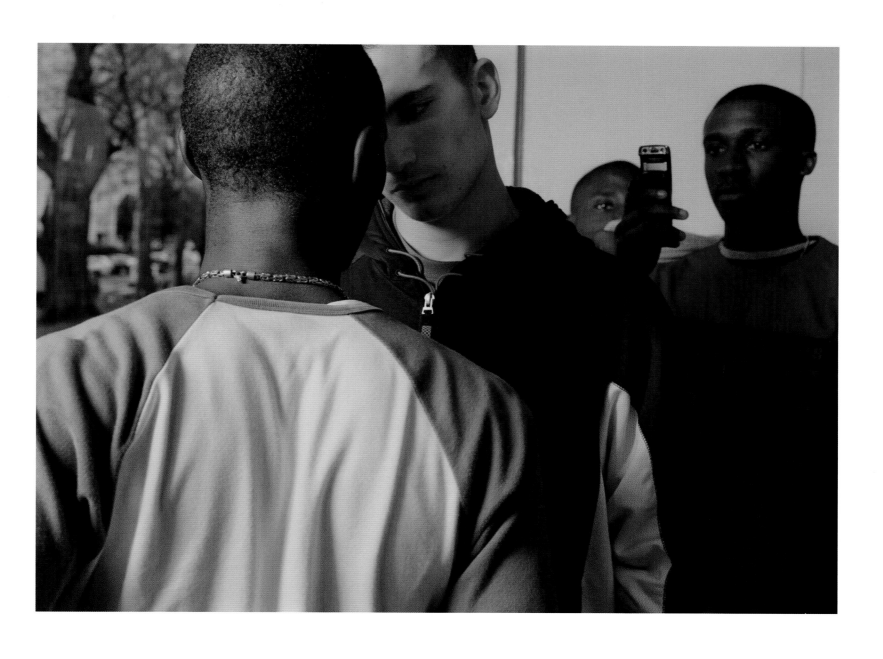

Hank Willis Thomas
Jermaine & Logan, 2002

Mohamed Bourouissa
Le téléphone, 2007–8

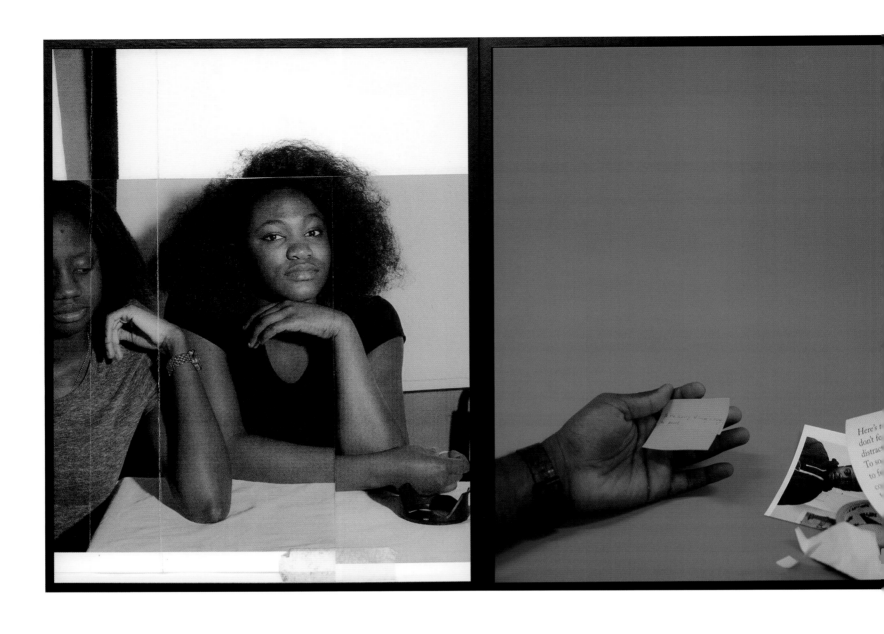

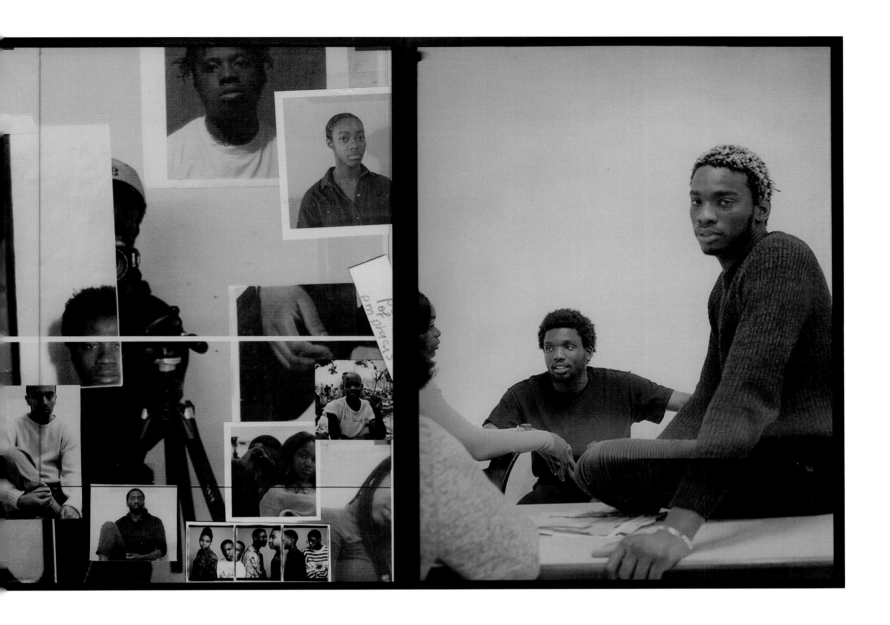

Barkley L. Hendricks always carried a camera; in our fifteen years of friendship, I never saw him without one. He termed it his "mechanical sketchbook," an expedient way to capture fleeting moments of inspiration that struck him. In this sense, the camera was as indispensable for him as charcoal and paper might have been for Rembrandt. A particular person, event, or vista could all be marked down on film and returned to later. At times, the camera was functional; the friends, acquaintances, and strangers depicted in Barkley's portraits first sat for his camera, enabling him to reference their comportment as he translated their essence into painting. As preparatory sketches, the photographs have a disarming immediacy. It is almost jarring to see Donald Formey, of Barkley's iconic painting *Blood* (1975), in the flesh, instantly recognizable by his wide-eyed gaze, distinctive plaid jacket, and Big Apple cap.

Barkley used his camera discerningly, despite its omnipresence. To be photographed by him felt special; something important had to capture his attention to be worthy of his lens. Consequently, even seemingly mundane images have a certain energy—for example, a radiant trio posed outside, emoting bemusement, joy, and resignation, the afternoon's shadows at play behind them: a modern-day Three Muses. Or two women photographed from the waist down (like fashion plates), hands on hips, their bright skirts and high heels a kaleidoscope of color and texture. Punctuated by Barkley's own shadow in the corner, the image is a surreptitious self-portrait of the artist in action, finding beauty in the simplest things.
—*Teka Selman*

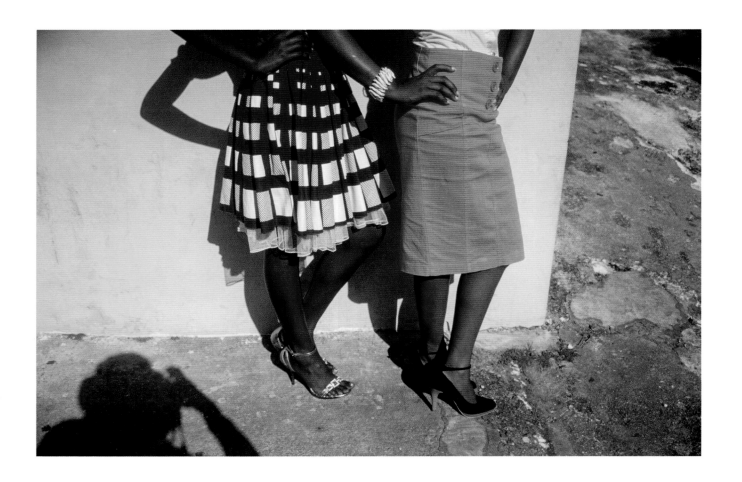

Barkley L. Hendricks
Untitled, ca. 2000

Untitled, 1982

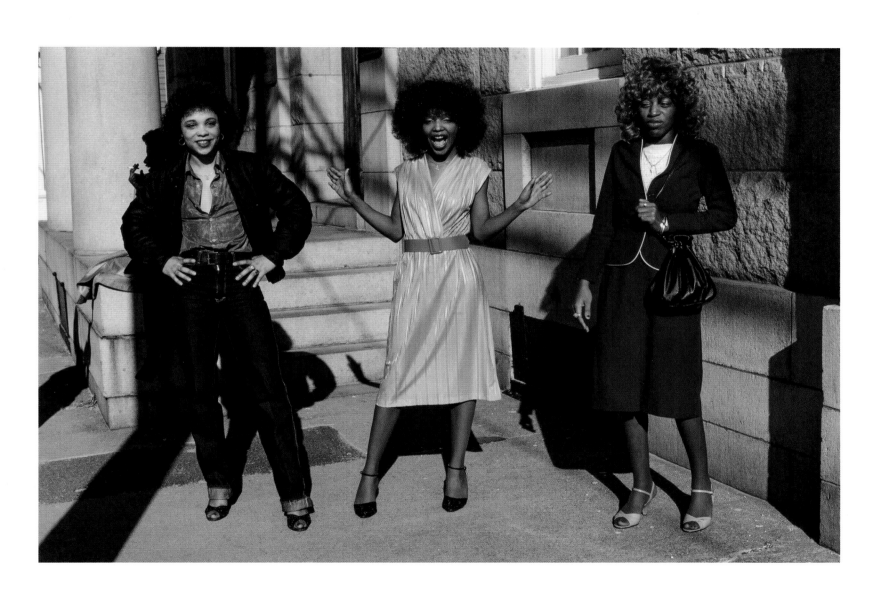

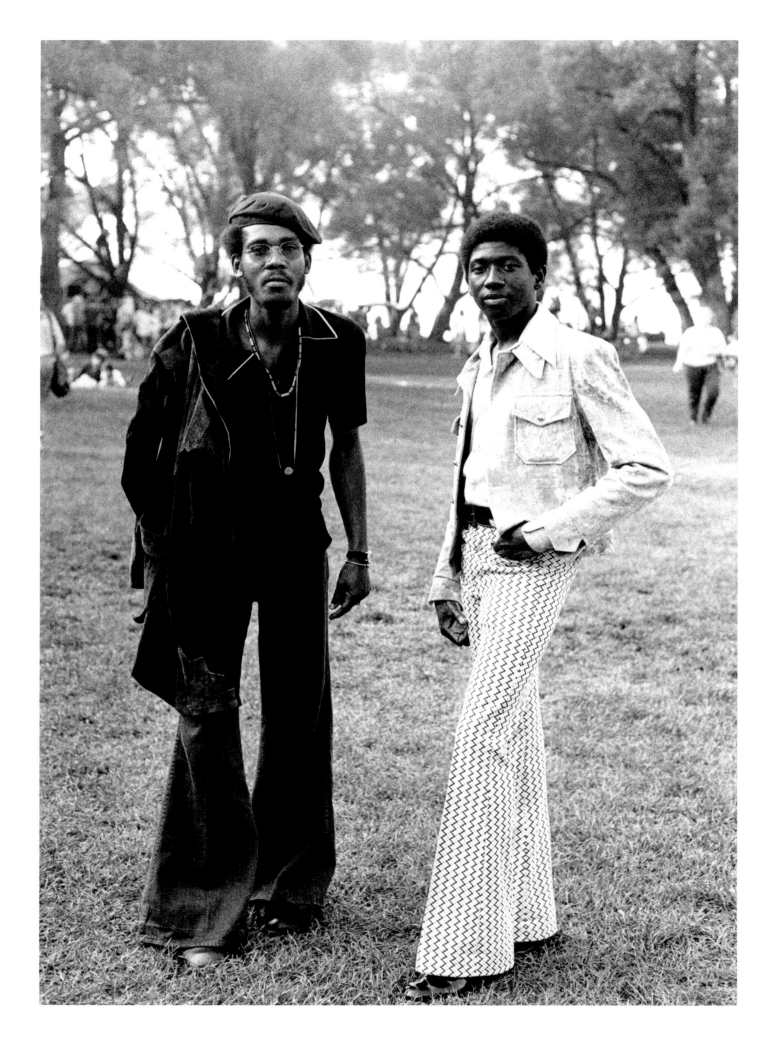

June Clark
Untitled, 1974

The Wig Shop
(1090 Bathurst St.)
4 June 1976

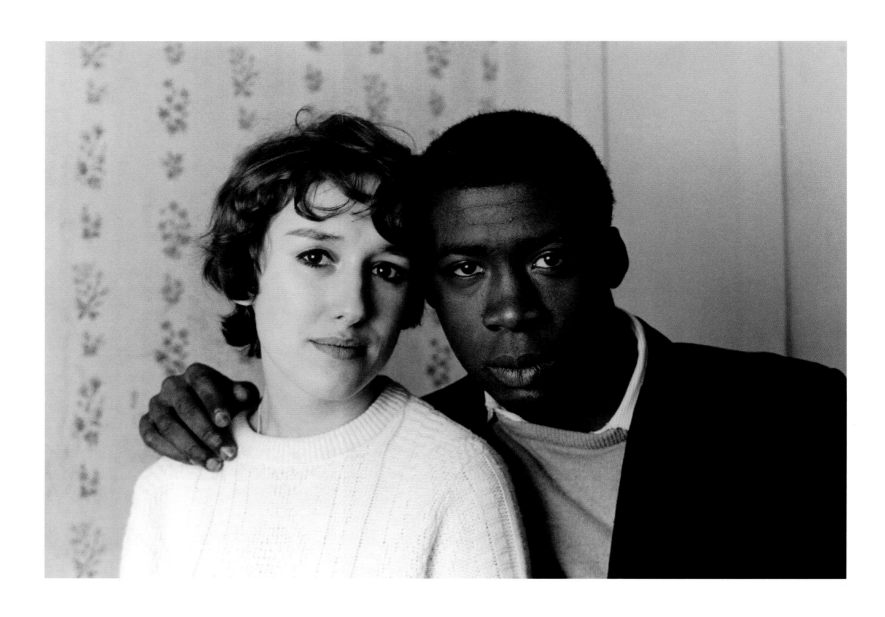

Charlie Phillips
Notting Hill Couple, 1967

Abdo Shanan
Untitled (Oran), 2014–16

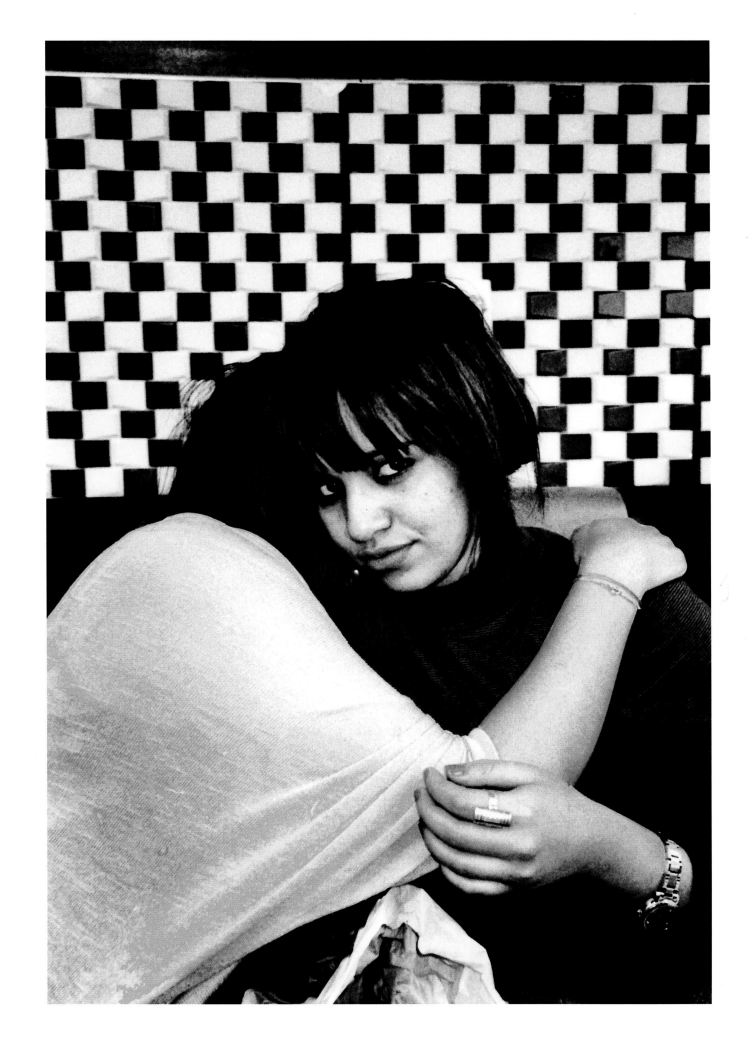

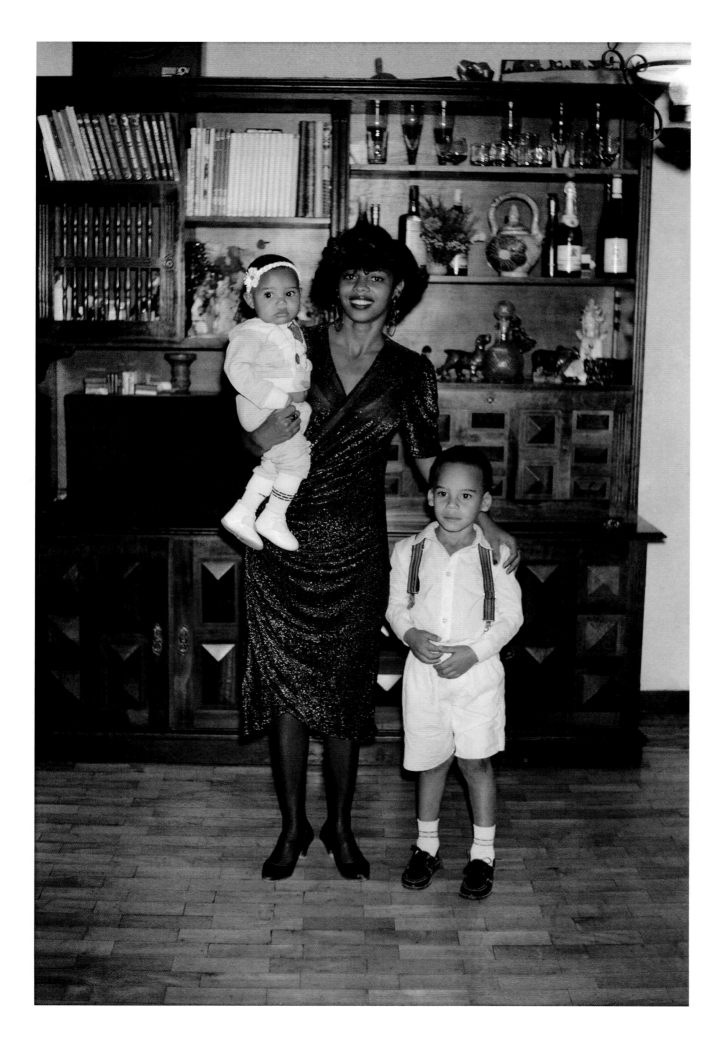

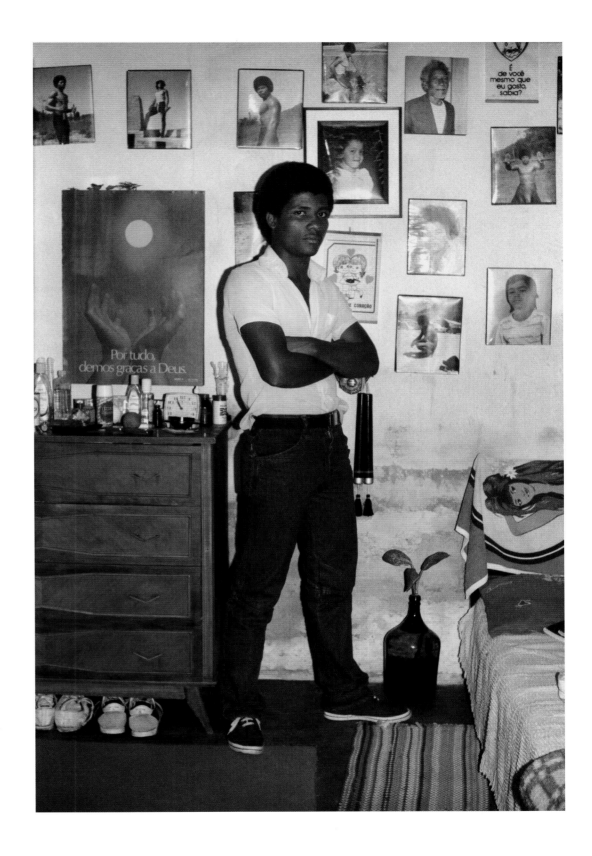

Afonso Pimenta
Cláudia and Children, 1989

Nivaldo's Portrait, 1986

Calvin Dondo
Charge Office, Harare, 2000

Andrew Tshabangu
*Butchery, Traders and
Taxis,* 2003; from the series
City in Transition

Louis Draper
John Henry, Lower East Side,
New York, 1960

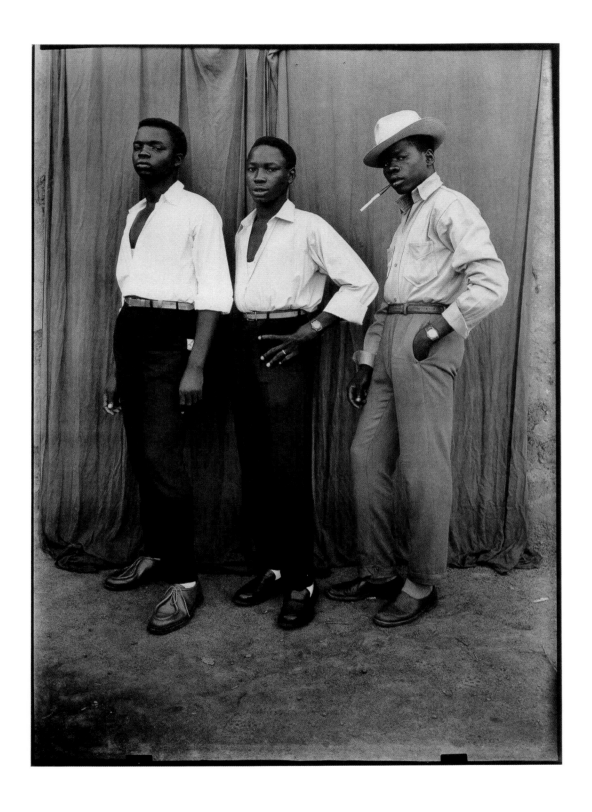

Community

Seydou Keïta
Untitled, 1952–55

Untitled, 1952–55

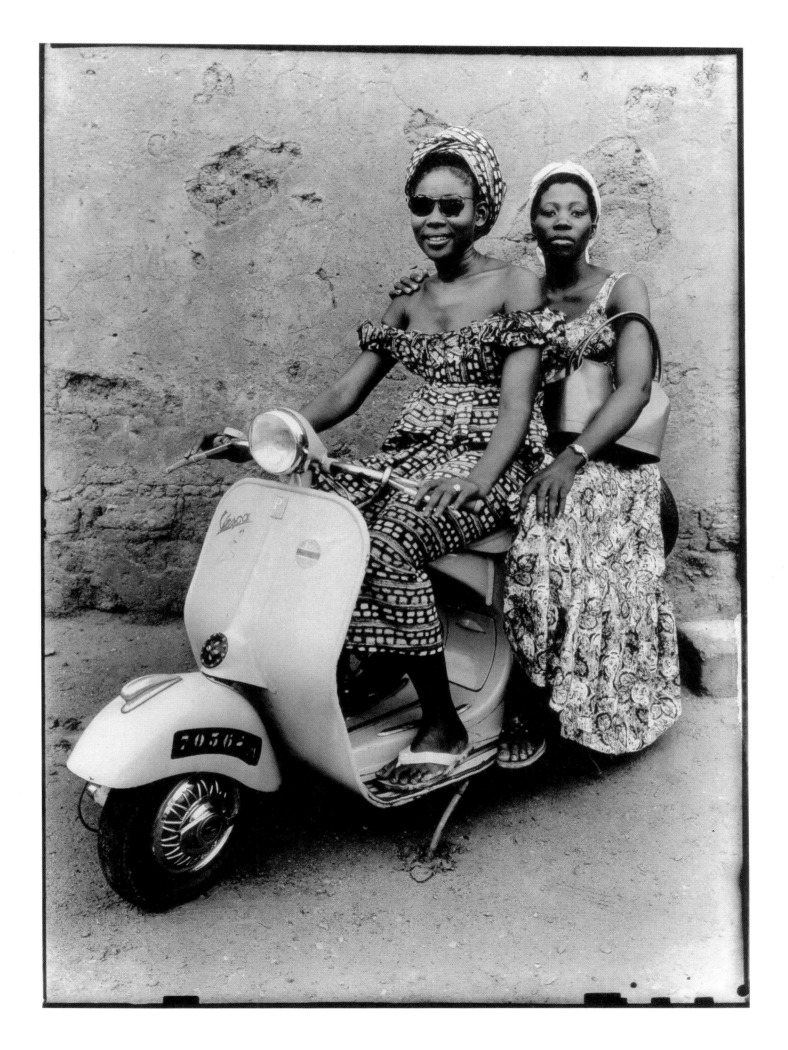

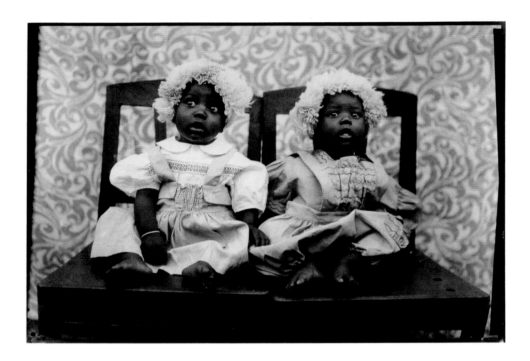

Seydou Keïta
Untitled, 1953–57

Untitled, 1952–55

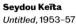

I first saw the work of Seydou Keïta in *In/sight: African Photographers, 1940 to the Present*—Okwui Enwezor's landmark survey show at the Solomon R. Guggenheim Museum in New York—way back in 1996. It was a life-changing experience.

Keïta was born in 1921 in Mali, where he opened one of the first photo studios in the bustling capital city of Bamako near the main train station. The country would break free from France and become an independent nation in 1960, and these timeless images from the preceding decade show a community that wants to move *forward*: their postures, dress, and attitudes all reflect this desire. The two stylish women on a Vespa (one rocking a new watch and handbag), are extremely cosmopolitan; their choice to include the scooter portrays them quite literally going places, heading off to the future (page 69). And the three young men in their crisp white shirts exude effortless style, working their movie star looks (page 68). What Keïta captures is quintessential West African modernism. His composition, choice of backgrounds, and placement of subjects are just killer. Sometimes, the texture of the concrete wall outside his studio anchors the pictures; other times, the contrast of patterns between the sitters' clothing and the drapery behind them provides a beautiful tension.

—*Kenneth Montague*

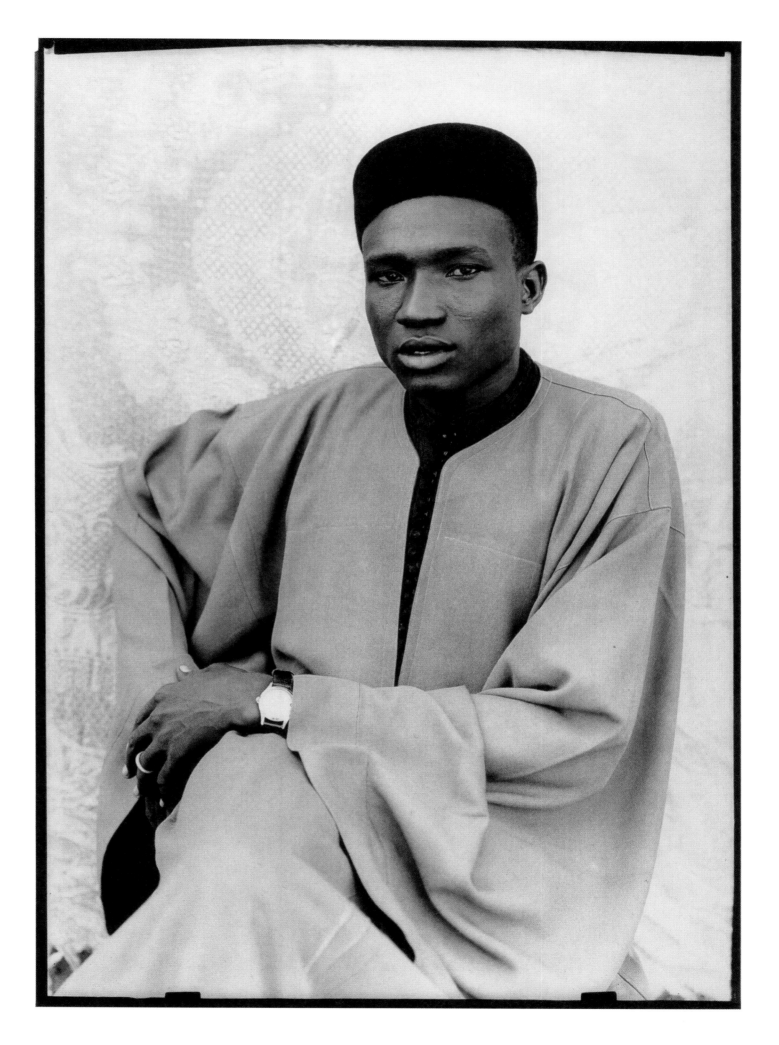

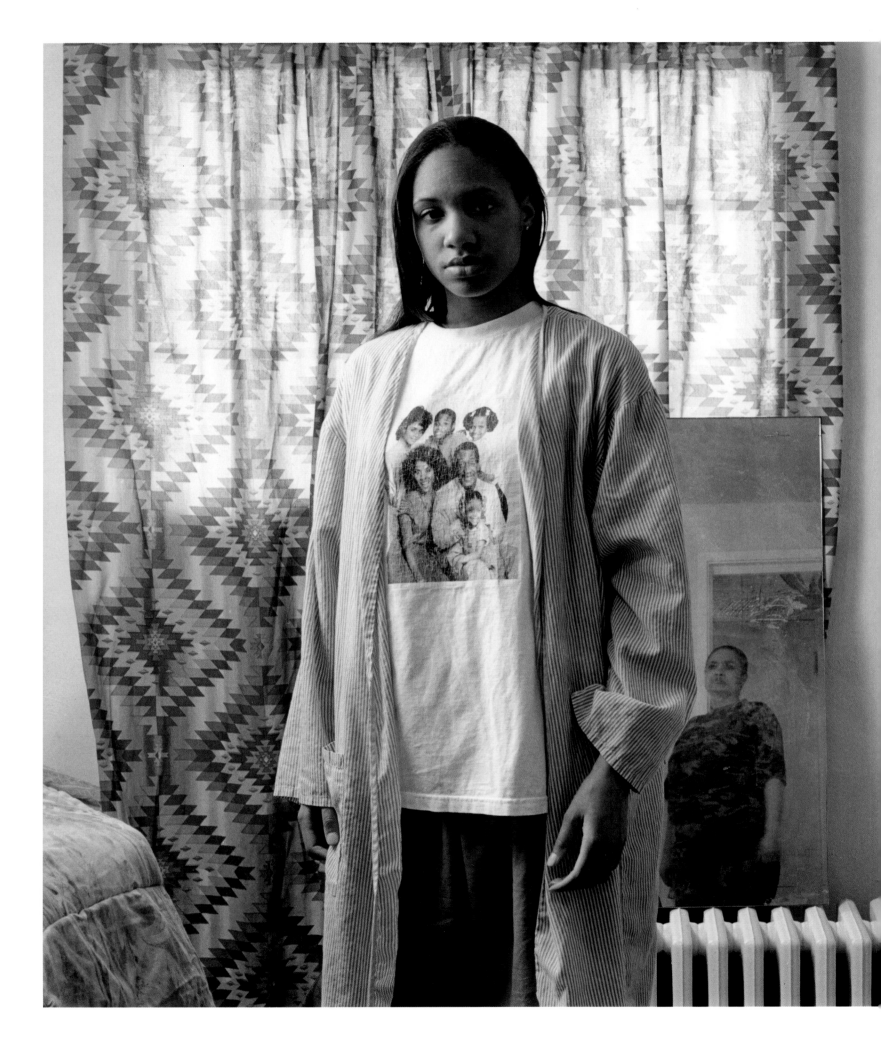

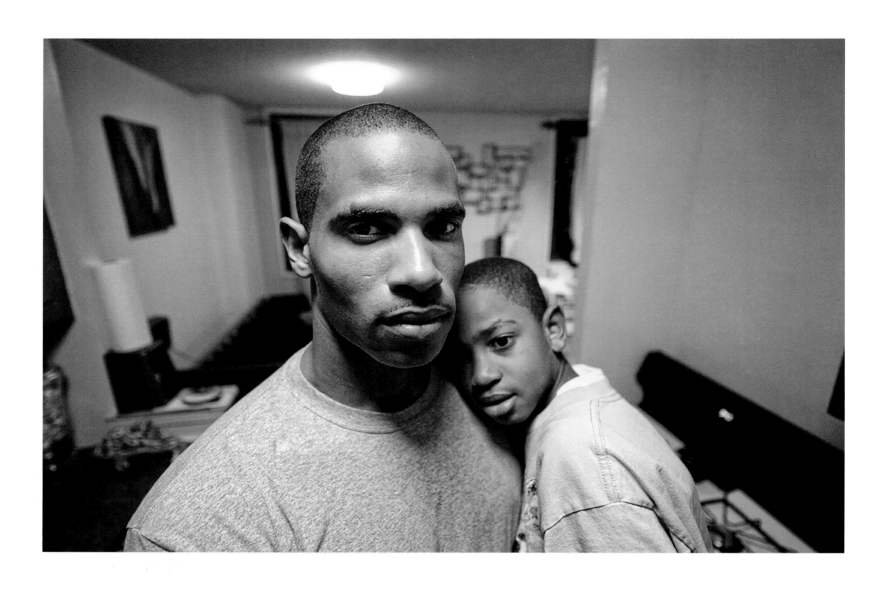

Zun Lee
*Jebron Felder and his son
Jae'shaun at home. Harlem,
New York, September 2011*

Aïda Muluneh
*Girl in the Car, Addis Ababa,
Ethiopia, 2001*

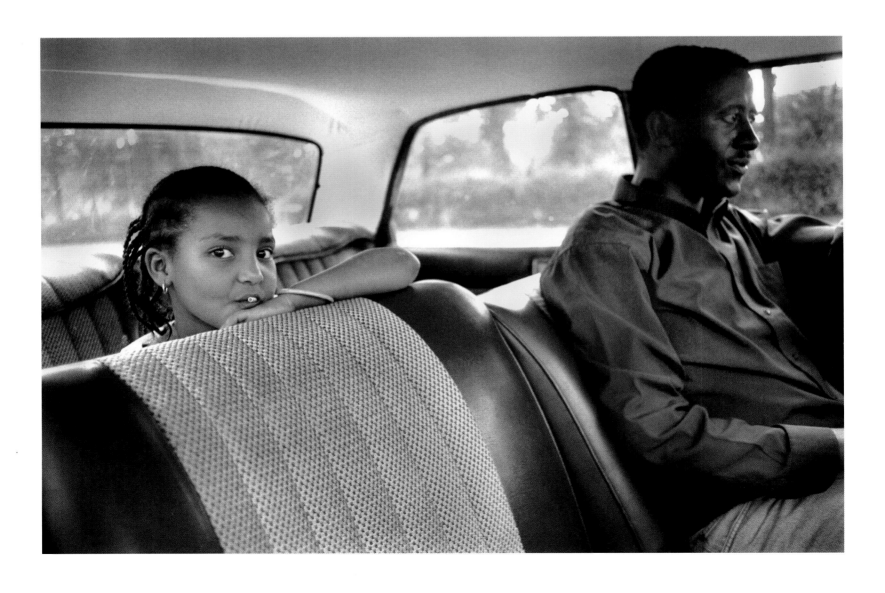

L. Kasimu Harris
*The Road Ahead (Morrisa and
Malcolm Jenkins)*, 2013

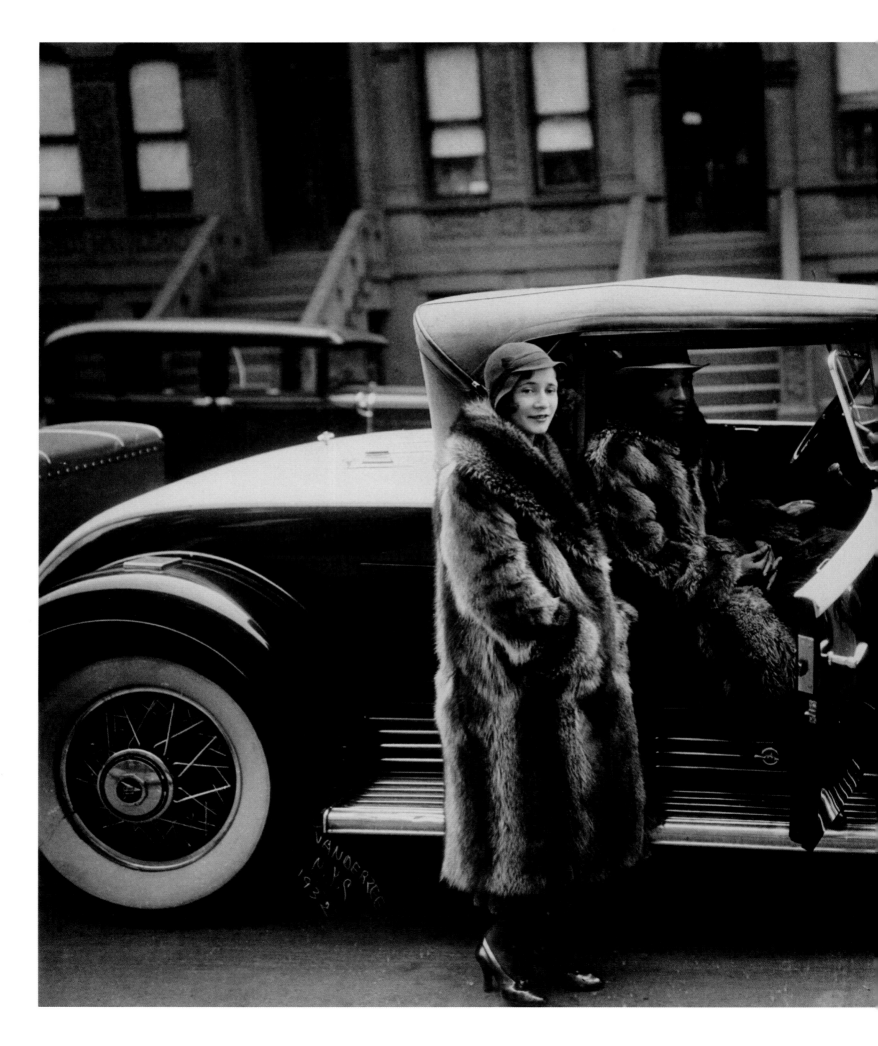

To James Van Der Zee, Harlem was home. His formal photographs, even those made on Harlem's streets, contain aspects of both ceremony and ritual, suggesting shared values, aspirations, and goals. In this image, an attractive couple dressed in matching fur coats poses with a shining Cadillac V-16 roadster, as if waiting for the photographer to construct the ideal pose to express their place in the community. *Couple in Raccoon Coats* (1932) symbolizes the celebration of Black life some seventy years after the end of slavery, during the cultural explosion of the Harlem Renaissance. As I look at this photograph, I reimagine this period in history through Van Der Zee's portrayal of the couple. I envision this image shared with family members in the city—the waves of Black immigrants from the Caribbean and migrants from the rural South. I imagine that Van Der Zee's photographs forever changed the visual self-image of the people who metamorphosed into fashionable big-city dwellers, the degradations of the past seemingly eliminated from their present lives.

Couple in Raccoon Coats raised a whirlwind of social and photographic questions when I first saw it at the Metropolitan Museum of Art's exhibition *Harlem on My Mind* in 1969. I made a total of five visits to view the groundbreaking show that year, and I was most curious about the Van Der Zee photographs. I wondered who Van Der Zee was and why he was not mentioned in any of my books on the history of photography; seeing the exhibition made me want to recover the personalities captured within his frame.

—*Deborah Willis*

James Van Der Zee
Couple in Raccoon Coats,
1932

79

Early self-commissioned portraits—daguerreo-types and cartes de visite—that circulated beginning in the 1840s of Black abolitionists Frederick Douglass and Sojourner Truth, may seem dramatically disconnected from the proliferations of today's iPhone selfies shared on social media, but are they really? Photography has always been a tool of influence and control, with a history of erasure, surveillance, and oppression; and for Black photographers, a history that includes self-representation and agency. The lives and works of Douglass and Truth teach us that the Black image-maker carries traditions of using their self-image to perform, connect, disrupt, protect, and heal.

This history takes many forms, and several works housed in the Wedge Collection underscore the varied and complex experiences that connect us to ourselves, and to one another. Iconic storytellers like Carrie Mae Weems and her seminal *Kitchen Table Series* (1990; page 109), and more recent familial homages like Lebohang Kganye's series *Ke Lefa Laka: Her-story* (2013; pages 110–11) couple self-portraits with the vernacular to bind and blur the lines between self and family, mother and daughter.

The Black body has weathered many false generalizations that delineate impossible beliefs yet continue to frame and subjugate. These failed characterizations have been reinforced through the dominant popular culture. Black artists counter and cajole these fallacies, affirming our multitudes. Challenging the restrictions of gender, class, and sexuality, Samuel Fosso has spent his career playing and satirizing biased tropes that have stigmatized the Black male. In an early studio self-portrait, a young Fosso poses stylishly, while donning platform heels (page 91). Through the years, using fashion and costuming, he has performed roles as priest, tribal chief, golfer, and dandy. These characterizations—like cloaks—are easily taken off, admitting their thin facade.

Black representation takes the form of rebuttal turned affirmation. Artist Erika DeFreitas photographs herself mouthing a quote by Zora Neale Hurston—"I am not tragically colored"—onto a pane of glass (page 89). It's a refusal and declaration aligned with the history of performing our self-worth, taught first by Sojourner Truth. Refusal shows up in Sandra Brewster's series *Blur* (2016–18; page 113), in which Black sitters are photographed in motion, denying the viewer a sense of knowable clarity. Here, opacity functions as a metaphor for the *being* and *becoming* of Caribbean migrant and diasporic experiences.

The urgent need to create in the confines of what is accessible is reflected in this chapter, as we are privy to the interior spaces of unguarded self-actualization. During the early days of the COVID-19 pandemic lockdown, with only the use of a camera and available light, Kennedi Carter made a sobering self-portrait (page 88)—eyes weary and alert, gazing directly at the viewer, while her father shaves her head; it underlines the vital beauty and importance of tender gestures of care. This moment laid bare brings to mind a 1968 interview with Nina Simone, in which she stated: "What I hope to do all the time is to be so completely myself . . . that my audiences and even people who meet me are confronted with what I am, inside and out, as honest as I can be. And this way, they have to see things about themselves, immediately." The truest representations not only serve oneself and close community, but also have the power to reflect, question, and impact the world around us.

Photography can be a device to exorcise, celebrate, and heal. Revelatory and defiant, Blackness is uncategorizable, boundless, familiar, and treasured. In this chapter, we see ourselves and allow ourselves to be seen; collective memory and inherent value extend beyond the frame.

—*Liz Ikiriko*

Identity

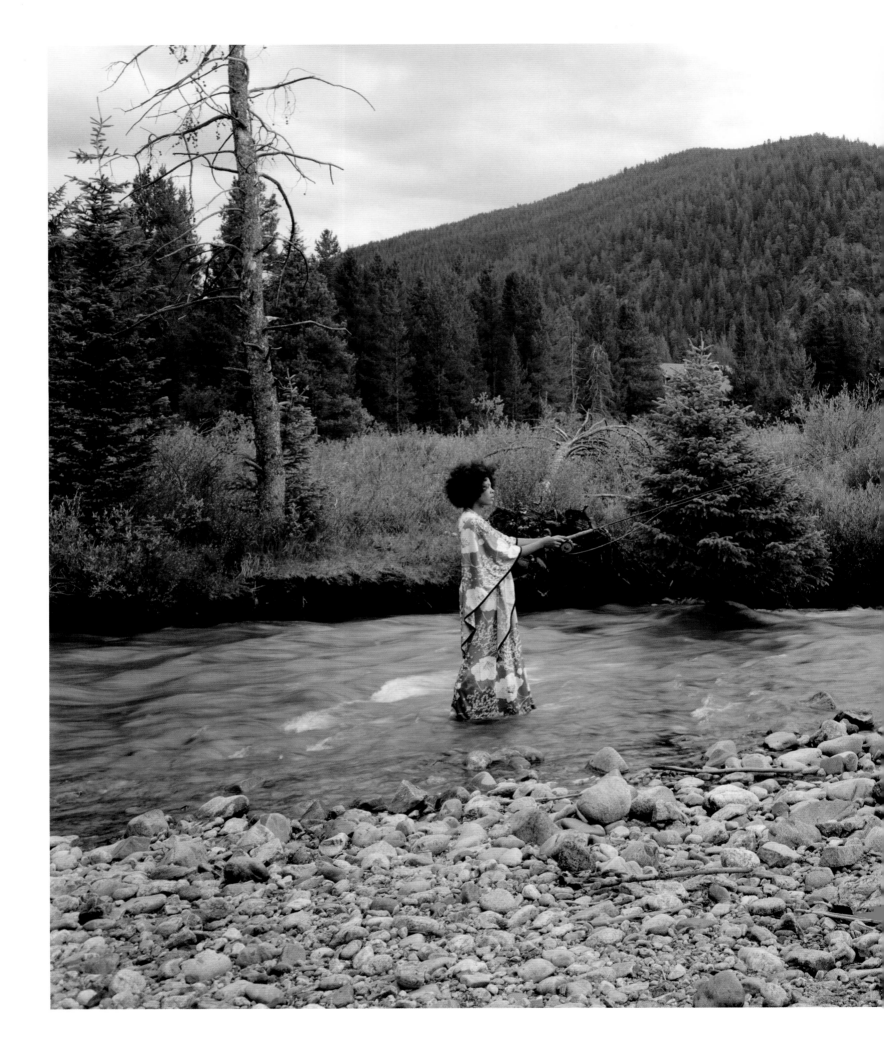

In *Denver* (2008), a photograph featuring a lone Black woman standing tall in the middle of a stream surrounded by the great outdoors, artist Xaviera Simmons reveals a concern for both nature and the human condition. Like the landscapes of the Hudson River School painters, Simmons's landscape offers a nod to the sublime in nature—the idea of a holy presence that permeates the sky and the land—and a yearning to return to a simple way of life.

For Simmons, there is great presence in absence. This image is part of a broader series of landscape photographs that engage with multi-layered ideas of spirituality, representation, and the natural world; Simmons also highlights her love of art history. Through the explicit act of insertion (in the literary sense, but also extending to the visual realm), Simmons posits characters in her images and intentionally extends the scope of the art historical canon, specifically landscape painting, to include Black people. In *Denver*, the figure is properly equipped and shown wearing a long, sumptuous green frock; her hair is full and beautiful. In her hands, she holds a fishing rod, allowing her to both live with and off of the land. There is something theatrical in Simmons's landscapes; in a sense, they serve as sets in which she positions her characters in a sculptural and performative manner. And it is in this context that Simmons utilizes nature, to establish Black people's undeniable presence, both past and present.
—*Isolde Brielmaier*

Xaviera Simmons
Denver, 2008

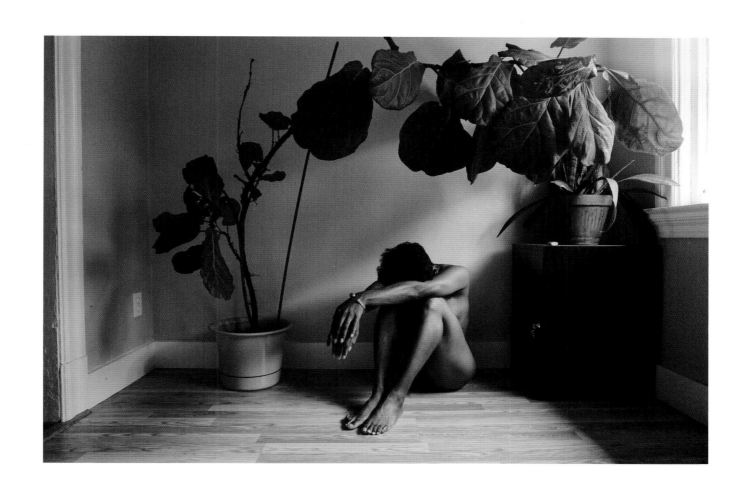

Mohamed Camara
From the series *Certains Matins*, 2006

Texas Isaiah
My Name Is My Name I, 2016

Carrie Mae Weems's *First Self-Portrait* is a unique vintage print from 1975, created when the artist was only twenty-one. The hole in the back of her white dress that exposes a mysterious whisper of Black skin and the mood created by Weems's body language make this an intimate picture, even though she chooses not to show her face. The glimpse of her home, with its many framed photographs within the image's frame, make it even more personal. When she recently visited me in Toronto and saw the work on display, Weems got quiet and simply said, "Oh, how wonderful to see this again."

Texas Isaiah's self-portrait *My Name Is My Name I* (2016, page 85), speaks to me for many of the same reasons: the vulnerability and sensuality of the subject at home, the powerful sense of self, and the exquisite light entering the plant-filled room. Texas Isaiah's commitment to increasing visibility for Indigenous, Latinx, transgender, and nonbinary communities makes him a critical voice in contemporary image-making. Both Weems and Texas Isaiah reveal more than they conceal, even as they refuse the traditional gaze of the camera.

—*Kenneth Montague*

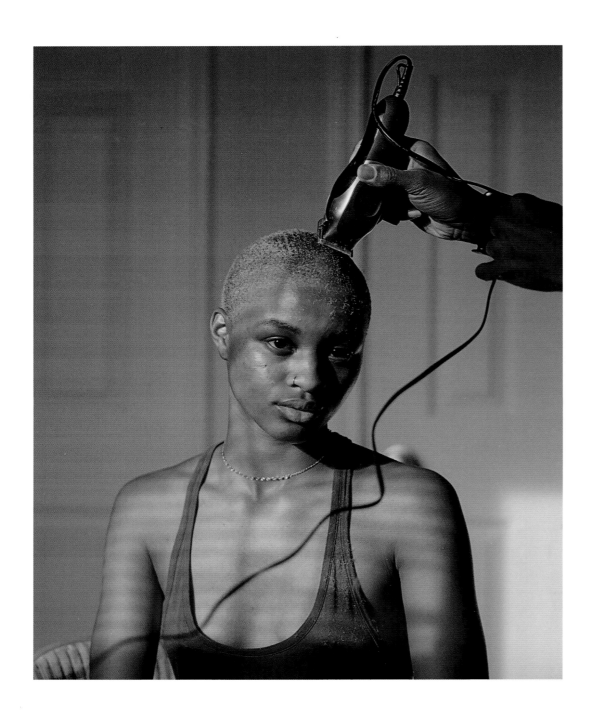

Identity

Kennedi Carter
Untitled (Self-Portrait),
2020

Erika DeFreitas
*I Am Not Tragically Colored
(after Zora Neale Hurston),*
2013–14

Samuel Fosso's decades-long practice of self-portraiture started in his studio in Bangui, capital of the Central African Republic, in the 1970s. This black-and-white image comes from one of his earliest series when, as a precocious fourteen-year-old photographer, Fosso turned nighttime in his studio into a theater for imagined selves. During the day, his photographic business thrived thanks to families', friends', and solitary sitters' commissions. At night, the unused frames of Fosso's rolls became blank pages for personal explorations of gender, masculinity, and postcolonial African identity.

In this image, the ostentatiously staged columns of spotlights, the mime-like pose, the flamboyant attire thrown over a slender body, and the dazzling festival of patterns in the background all concur to create a performance of quiet extravagance and cool nonchalance. This self-presentation is strikingly at odds with the military dictatorship that had been established and embodied by the ogrish Jean-Bédel Bokassa since 1966. Like Fosso, Bokassa was a very conscious participant in the politics of clothing; his parading of his military decoration—and his megalomaniacal coronation as emperor in 1977—was a spectacle of heteronormative and tyrannical masculinity in power, which Fosso's young and queer silhouette playfully but steadily dismissed in his studio. Those compensated boots, topped with flossy pants, loudly stated that they marched to their own beat, or even better, danced to their own tune. Fosso's personas were all infused with the same sounds, looks, and energy as the African American civil rights heroes and famous musicians that he would honor years later in his 2008 series, *African Spirits*.
—*Sandrine Colard*

Kwame Brathwaite
Sikolo Brathwaite,
African Jazz-Art Society
& Studios (AJASS),
ca. 1968

Self-Portrait, AJASS, Harlem,
ca. 1964

Eileen Perrier
Untitled, 2000;
from the series *Grace*

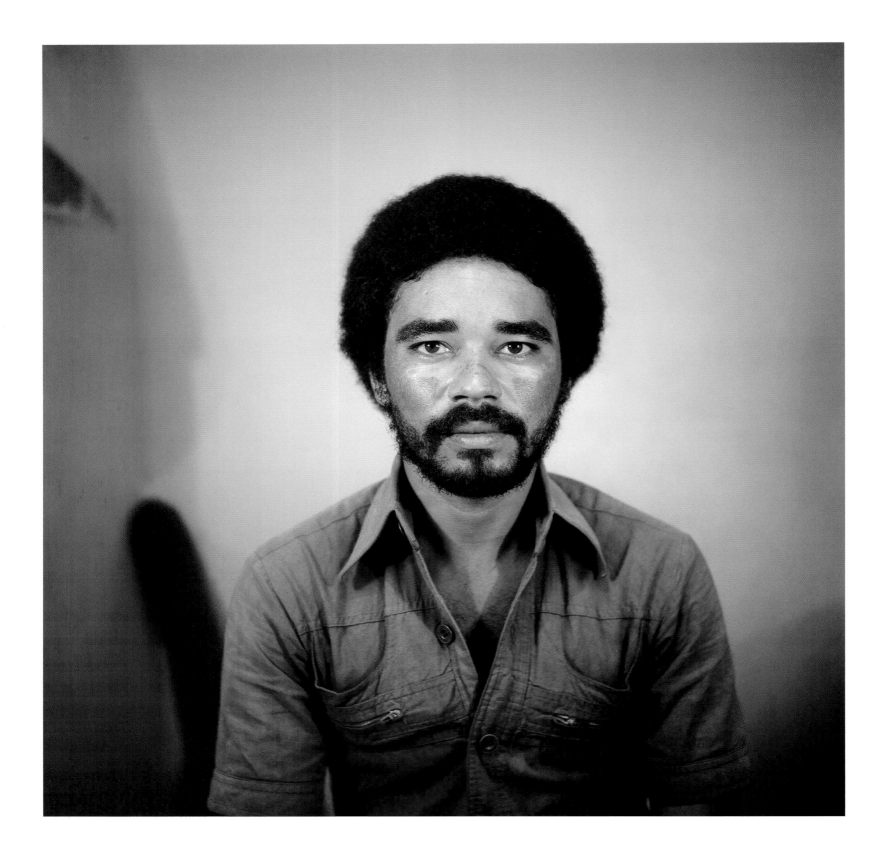

João Mendes
From the series *Studio Portraits*,
1979

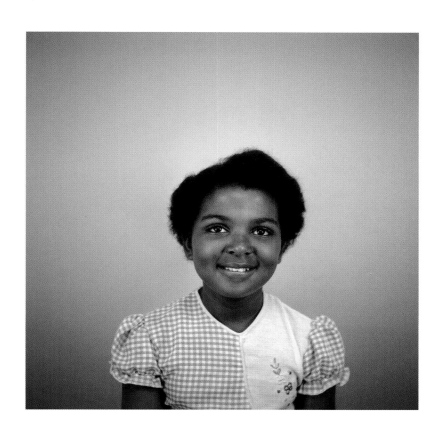

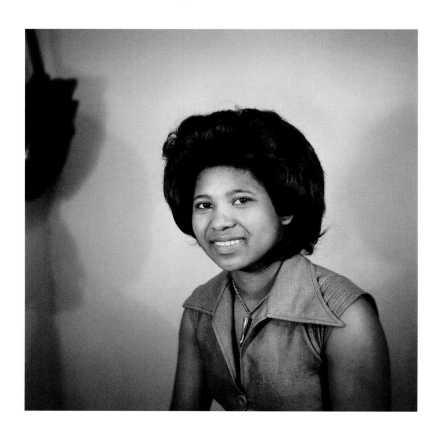

Oumar Ly was a self-taught, improvisational photographer from Senegal who, in 1963, was the first to open a photo studio in rural Podor. Ly began his practice making portraits for identity cards issued by the Senegalese government, then newly independent from France. His innovative techniques for creating outdoor photographs often involved recruiting assistants to hold up a blanket as a backdrop—their hands visible at the edge, or their silhouettes seen through the sheer fabrics. Other times, an assistant's flowing boubou becomes a makeshift background for a grand portrait.

In 2009, while attending *Bamako Encounters*—an essential biennial survey of contemporary photography from all regions of Africa—I paid a visit to the studio of the celebrated Malian photographer Malick Sidibé. As we sat on his front porch looking at pictures from his archive, an elegantly dressed, older gentleman arrived to pay his respects. It was Oumar Ly. There was a lot of laughter. I wish I knew what they were talking about, but I couldn't keep up with them in French. Mostly, I reveled in the magnitude of the moment: two of the greatest portrait photographers of their day, meeting for the first time.

—*Kenneth Montague*

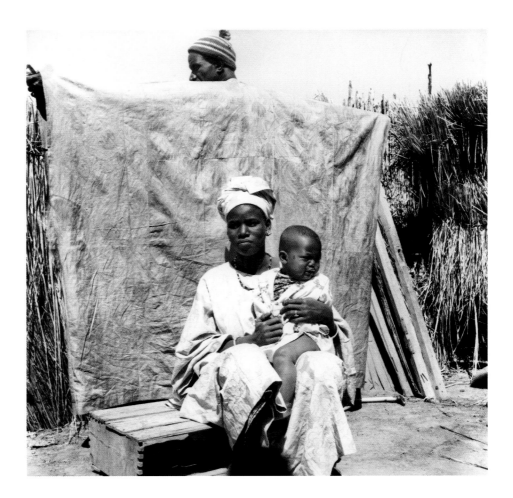

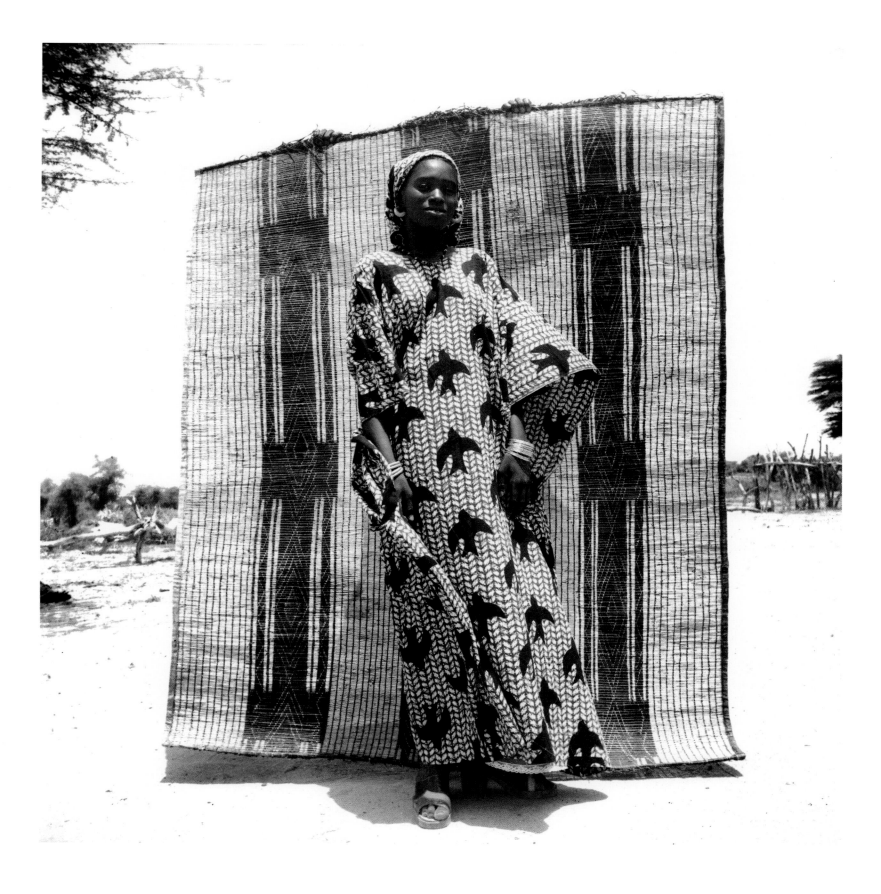

Arriving from Jamaica at age five, Dennis Morris grew up in East London, where he became a camera fanatic who, at age eleven, had a photo featured on the front page of the *Daily Mirror*. At thirteen, he skipped school to wait for Bob Marley to arrive for a sound check at a local music venue; Marley was so taken by the eager and talented teenager that he invited Morris to join him as official photographer for the remainder of his 1973 UK tour. When the Sex Pistols saw the Marley photographs, they gave Morris unrestricted access to trail the band for the entire chaotic year of 1977. The resultant images have become classics of both the reggae and punk eras.

However, it is Morris's very personal document of his own community from his youthful days in Hackney that truly speaks to me as a Jamaican Canadian. His series *Growing Up Black* presents the joy and pain of Caribbean immigrants in 1970s London—at home, in church, on the street, and in the dance hall. These images make powerful statements of personal identity, especially *Sister Cool* (1974), the stylish young girl with her two pairs of sunglasses and glacial stare, as if to say, "I see you. Do you see *me*?"

—*Kenneth Montague*

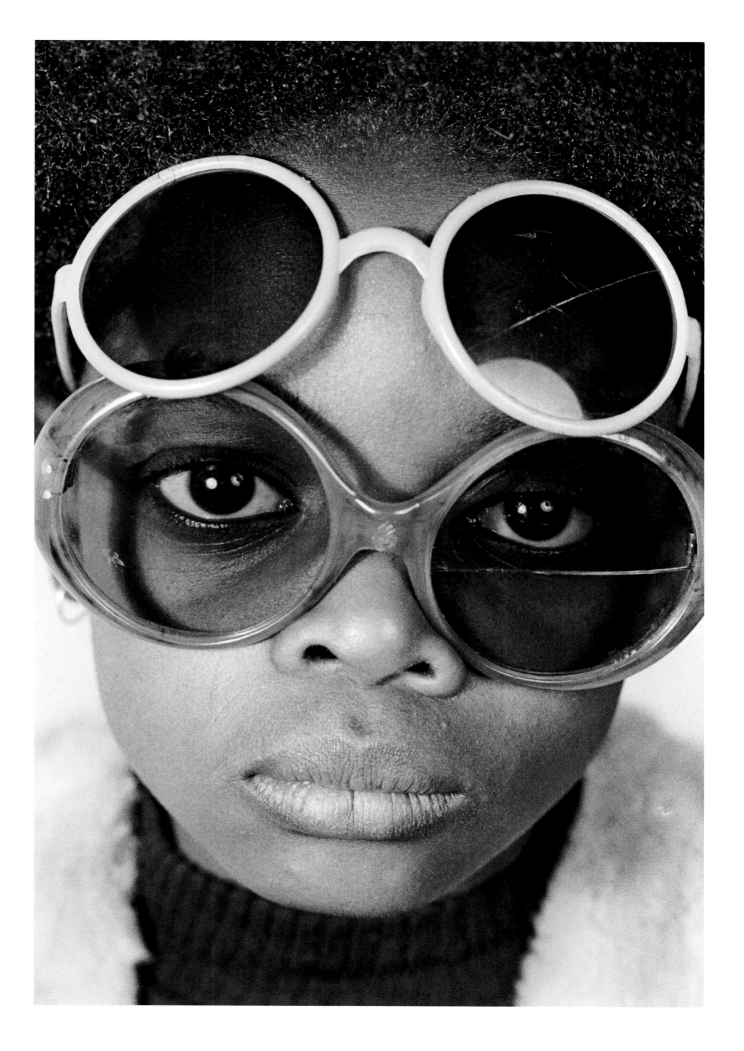

Rotimi Fani-Kayode
Twins, 1985

This image powerfully harnesses the contrasting dual symbolism of twins across Nigerian cultures. For the Yoruba people of southwestern Nigeria, twins are auspicious, praised from birth as supernatural beings protected by Sango, god of thunder, and bringers of wealth and good fortune (though were one twin to die, a bad omen would be anticipated). By contrast, in the southeastern region, the Igbo traditionally viewed twins as supernatural bringers of devastation. Rotimi Fani-Kayode was from a prominent Yoruba family, and these equally powerful but opposing symbolisms would have been known to him.

A founding member and first chairman of the UK's influential Autograph ABP (Association of Black Photographers), Fani-Kayode famously described himself as an outsider on three counts: in relation to his sexuality as a gay man; the weight of unmet familial expectations placed upon him (designed to uphold high-powered employment and social strictures, which he rejected as an artist); and "in terms of geographical and cultural dislocation," which he experienced acutely in Britain, where he relocated as a boy as a result of the Nigerian Civil War and the military coup that had preceded it.

Twins are a subject to which Fani-Kayode returned over the course of his all-too-brief, brilliant oeuvre. Within these works exists a powerful kinship between subjects, an unspoken understanding and closeness that they alone share—even if onlookers and the world beyond are unable to grasp it. In their two-ness is a completeness that cannot be divided.

—*Zoé Whitley*

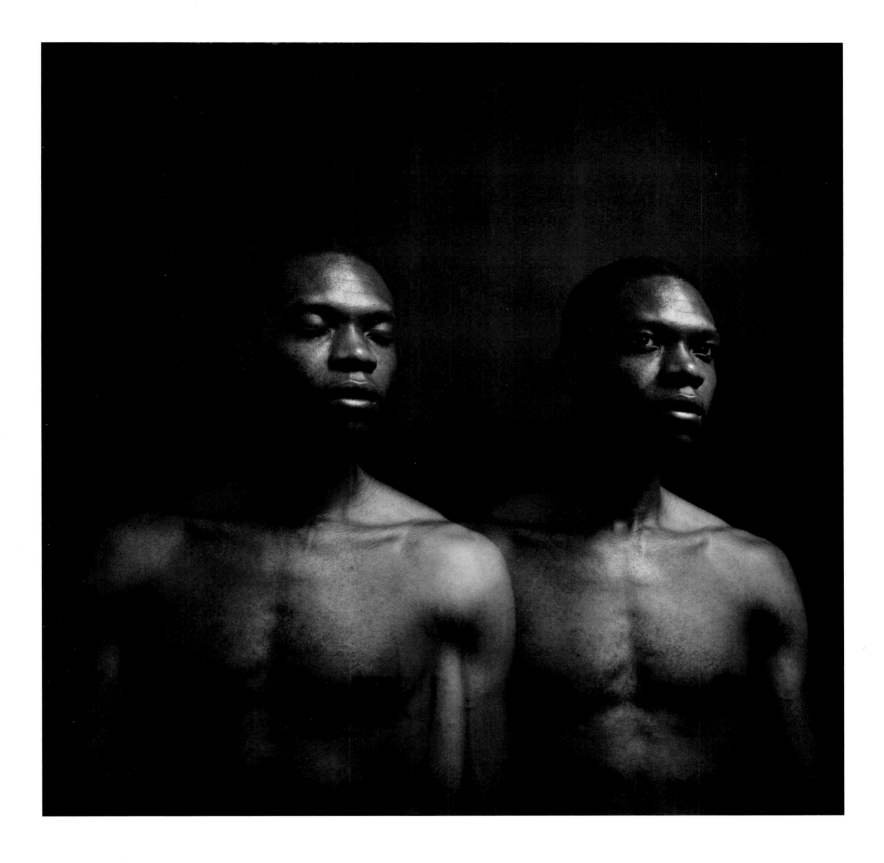

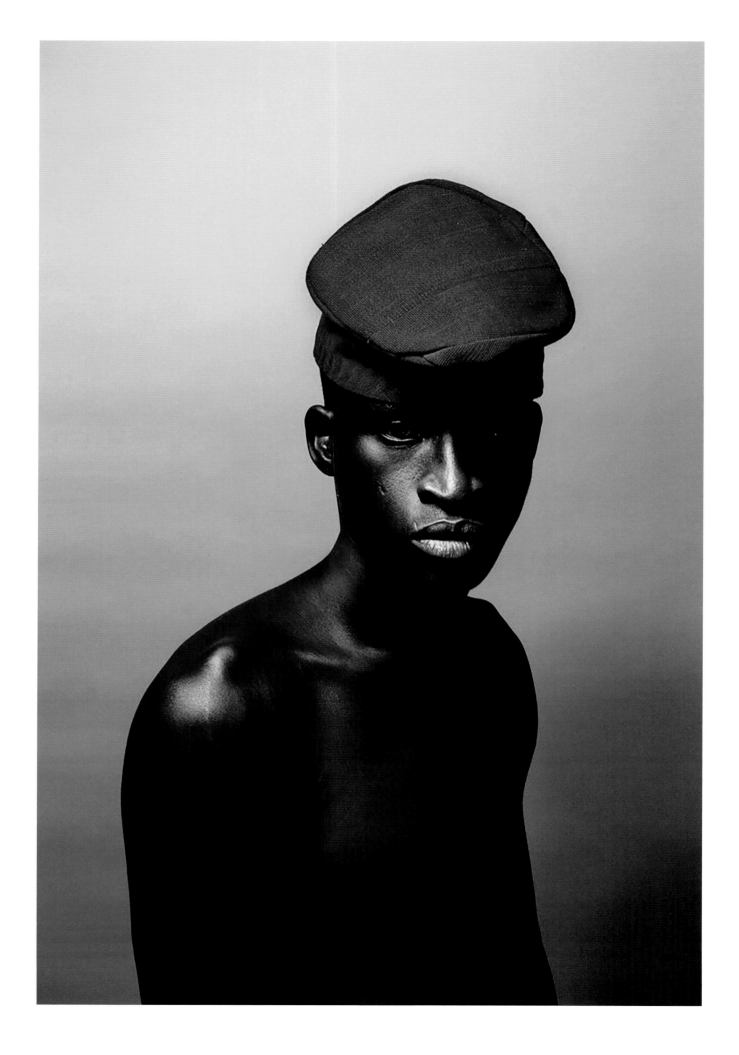

Lakin Ogunbanwo
Untitled (Purple Hat), 2013

Untitled (Hat on Face), 2013

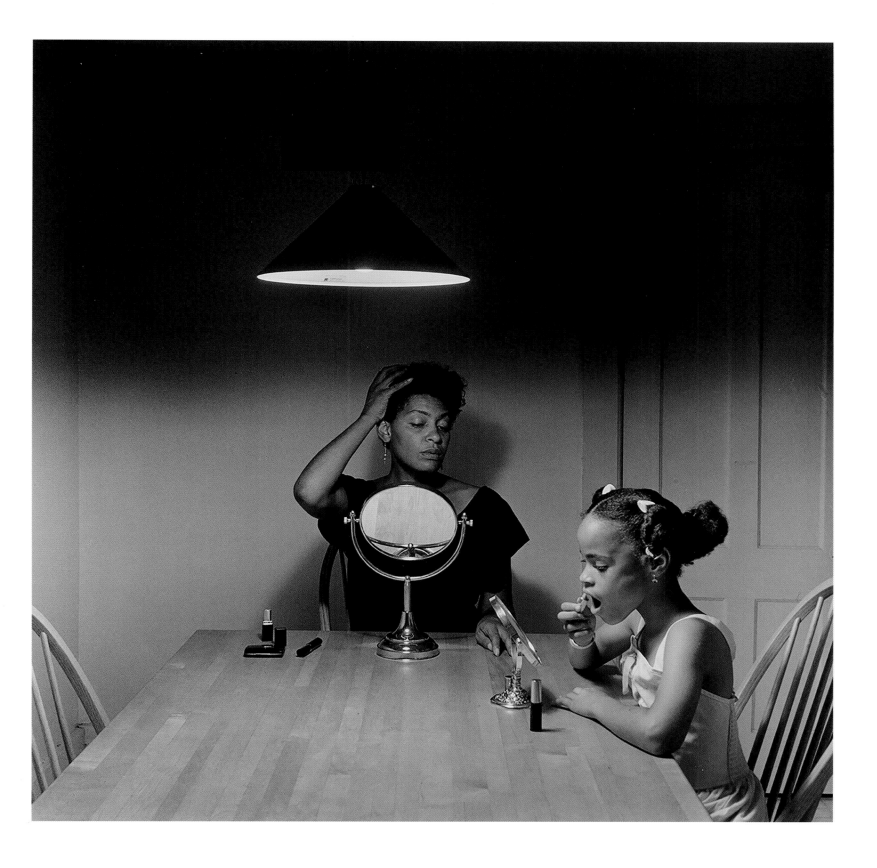

Ke Lefa Laka: Her-story (2013), the photographic series from which this picture is taken, originates in the loss of the artist's mother. Going through her loved one's possessions, clothes, and photo albums, Lebohang Kganye initiated a memory work about her mother's life and family history that expanded into a reflection about the past of her home country of South Africa. Like the rest of the series, this photograph is a digital juxtaposition of a portrait of Kganye's mother with a photographic copy reenacted by the artist herself in her mother's clothes; here, both wear a glorious pink dress. In many African photographic cultures, wearing clothes cut from the same textile is an expression of kinship or affective bonds, particularly between women. Such newly tailored garbs were, and still are, occasions for picture-taking, and this type of mirrored image emerged as a genre in the modern African studios.

Here, Kganye's reinterpretation of that tradition trumps the separation caused by death, but also the dislocation of family that resulted from apartheid's segregationist and disenfranchising laws. Like a majority of Black South Africans, Kganye's elders suffered forced displacement, land confiscation, and even their names' alteration, causing physical distance and emotional estrangement. Born right at the end of the apartheid regime and raised by her mother, the artist brings the two women closer together; in her practice, Kganye strives to reconnect members of her family, and more generally, to redress within the image some of the many crimes in South Africa's past. In the series, Kganye's evanescent figure affixed to that of her mother appears as an emanation of the latter's, as her "ancestors' wildest dreams."

—*Sandrine Colard*

Identity

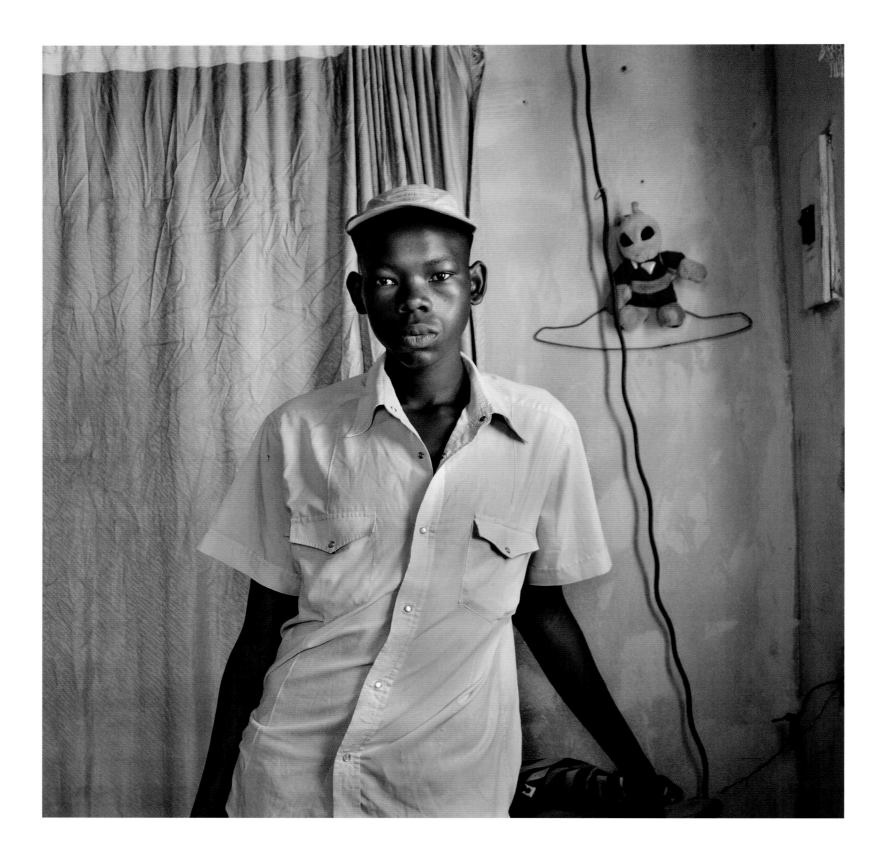

Identity

Jabulani Dhlamini
Solly Sefako, Phiri, Soweto,
2012

Kwa Mandebele, Zenzeleni,
Warden, 2013

This image of aspiring model Erlin Ibreck underlines James Barnor's exuberant zeitgeist during the aspirational 1960s—a period marked by social and political transformation in Barnor's native Ghana, and a then-emerging Black diasporic identity and modernity in the United Kingdom, where Barnor has lived on and off since 1959. In 1953, Barnor established Ever Young studio in Jamestown, in the heart of Accra, in the lead-up to Ghana's independence from Britain in 1957. Barnor became a significant chronicler of the nascent country, indexing the remarkable joie de vivre of a society in transition and a tenor of postcolonial nation-building. Moving to London in 1959, Barnor emplaced himself in Black circles. His riveting photographs included intimate portraits, everyday life, social activism, and political engagement of West African and Caribbean immigrants who had made the capital of a crumbling empire their home.

This saturated photograph taken in 1966 suggests Barnor's keen eye, and his key role in outlining the sociological contours of a vibrant, multicultural London. The nineteen-year-old Ibreck is leaning delicately on the side of a sporty Jaguar and staring calmly into and beyond the camera lens. Her surroundings are a blur of sidewalk, tree trunk, columns of trees and cars in the background. Ibreck's chic fashion mirrors Swinging Sixties London. This is an image of time and place, but it outlives its temporality and specificity, what the cultural theorist Tina Campt may refer to as a "recalcitrant" image. Barnor photographed Ibreck as a cover girl for *Drum*, the influential Pan-African lifestyle magazine that challenged apartheid South Africa's racial stereotypes by presenting cosmopolitan images of Black people in society. A remarkable symbol of refutal in its time, the timeless image conjures this momentous period of decolonization and postcolonial modernism.

—*Ugochukwu-Smooth C. Nzewi*

James Barnor
Drum Cover Girl Erlin Ibreck,
Kilburn, London, 1966

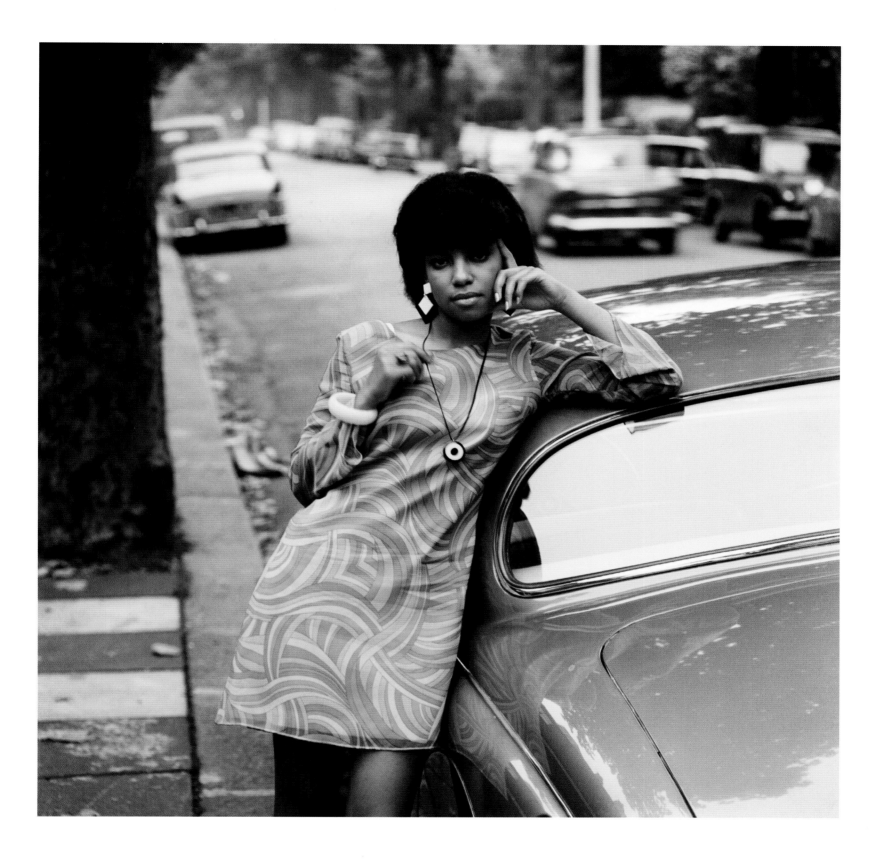

Dawoud Bey
*A Boy in Front of the Loew's
125th Street Movie Theatre,
Harlem,* 1976

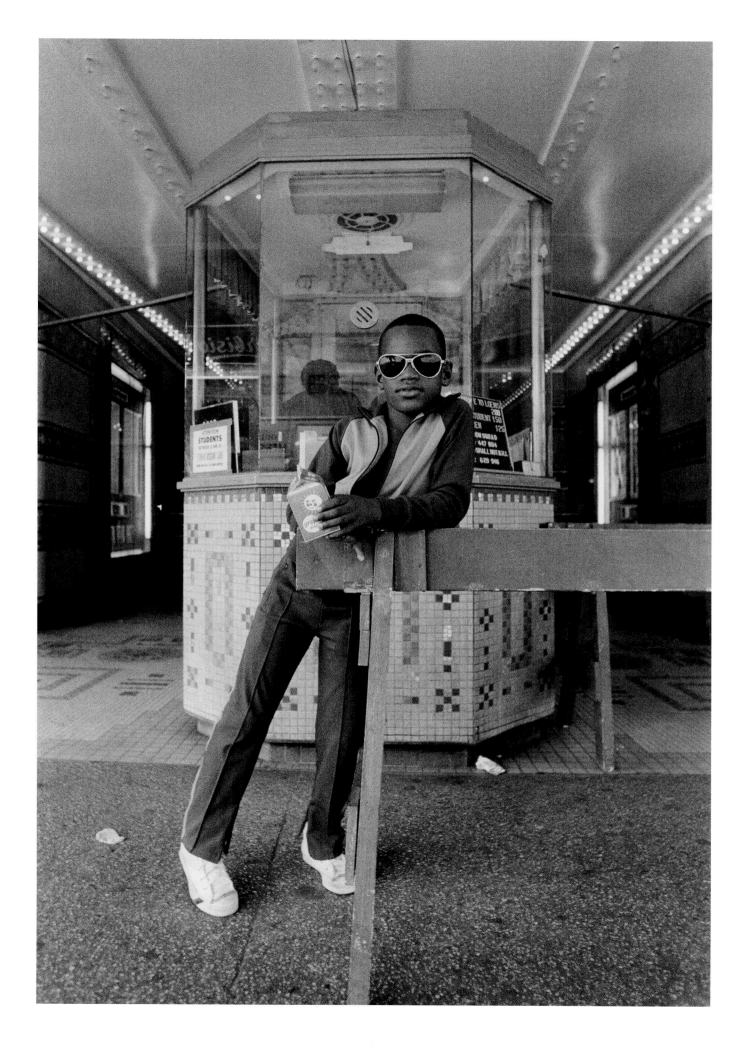

Nontsikelelo Veleko
Vuyelwa, 2003–7

Arielle Bobb-Willis
Union City, New Jersey, 2018

Consider William Cordova's practice as an alchemic manifestation of an indisputable truth—that we are all small parts of a larger web, regardless of whether we see it, know it, or ever intersect. Once this fact is accepted, a dominant narrative becomes impossible, creating the freedom to notice things we would otherwise pass by, value what is too often overlooked, and center what has been unwittingly pushed to the periphery. The many small moments that build a life might be mirrored elsewhere in time or space, as much as they might be new creations to be reexperienced at some point in the future.

Badussy (or Machu Picchu After Dark) (2003–9) could be an incarnation of this thesis. Both a video work and a photograph, it might be fiction or documentary—its female protagonist sitting on a fence, hands weaving something indiscernible while the sounds of folk music float through the background. In her T-shirt, rolled-up jeans, striped knee socks, and sneakers, boom box at her feet, she could be a teenage girl from anywhere, familiar and timeless. Yet the scene is difficult to discern; too many things are happening at once, the mundane and the unknown rubbing up against each other as if in a dream. Consequently, the work is made sensible only through what our individual perspectives bring—the entry points determined by your cultural home base. Time and space fold in on themselves while associations collide, sink, and resurface—everything, after all, is relative.
—*Teka Selman*

William Cordova
Badussy (or Machu Picchu After Dark), 2003–9

Jody Brand
Moffie in Irma's Garden, 2017

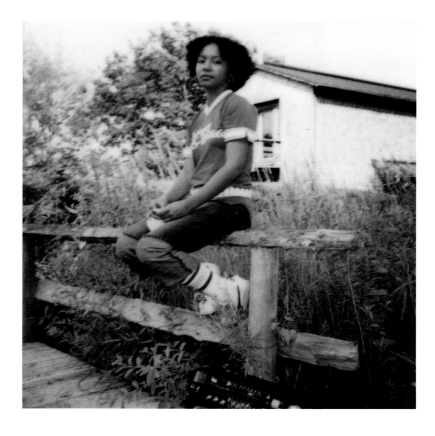

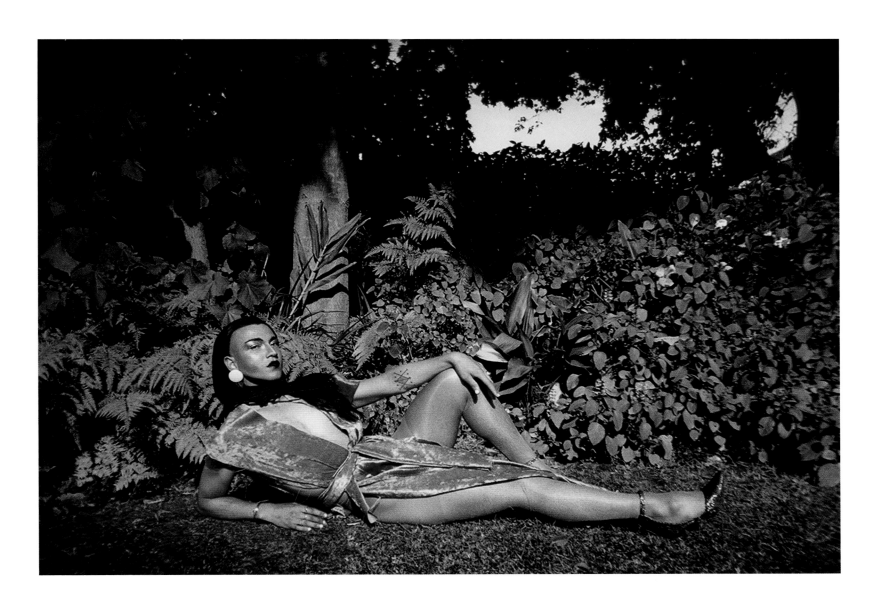

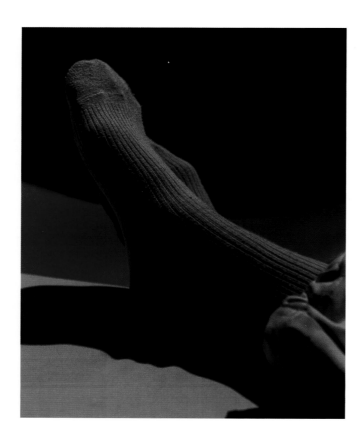

Elliott Jerome Brown Jr.
For Your Birthday I Gave You a Framed Print of This, with a Pair of Matching Saucony Sneakers, 2015

Devin in Red Socks, 2016

Informed by the singular details found in private and public spaces, the work of Elliott Jerome Brown Jr. explores the limits and possibilities of photography. Playing with the frame of the image and what gets to be revealed or hidden, his work invites the viewer to question what is seen and what isn't, and how the image tells a story. Constructing fragmented pieces of intimate narratives, the artist blurs, layers, and complicates the lines between portraiture, documentation, and revelation. For me, his practice demonstrates a right to opacity as defined by poet Édouard Glissant: "Agree not merely to the right to difference but, carrying this further, agree also to the right to opacity that is not enclosure within an impenetrable autarchy but subsistence within an irreducible singularity."

Indeed, Brown's practice offers a counterargument to the canon. His images seem to do the hard work of asking us to consider what are the various ways Black stories can be told, healed, experienced, and disseminated. Attentive to the inherent relationships of image-making to power, the artist's lexicon aggregates information in subtle ways, rendering it impossible to only draw one read out of an image. In these two images, the mundanity of socks becomes an affect toward pleasure, intimacy, and care. The images trigger us to look beyond what we recognize, to better consider our feelings about the visual. In many ways, Brown's practice not only captures, but it also embodies and expands what the abstraction of daily Black life can be in the collective realm of consciousness.

—*Daisy Desrosiers*

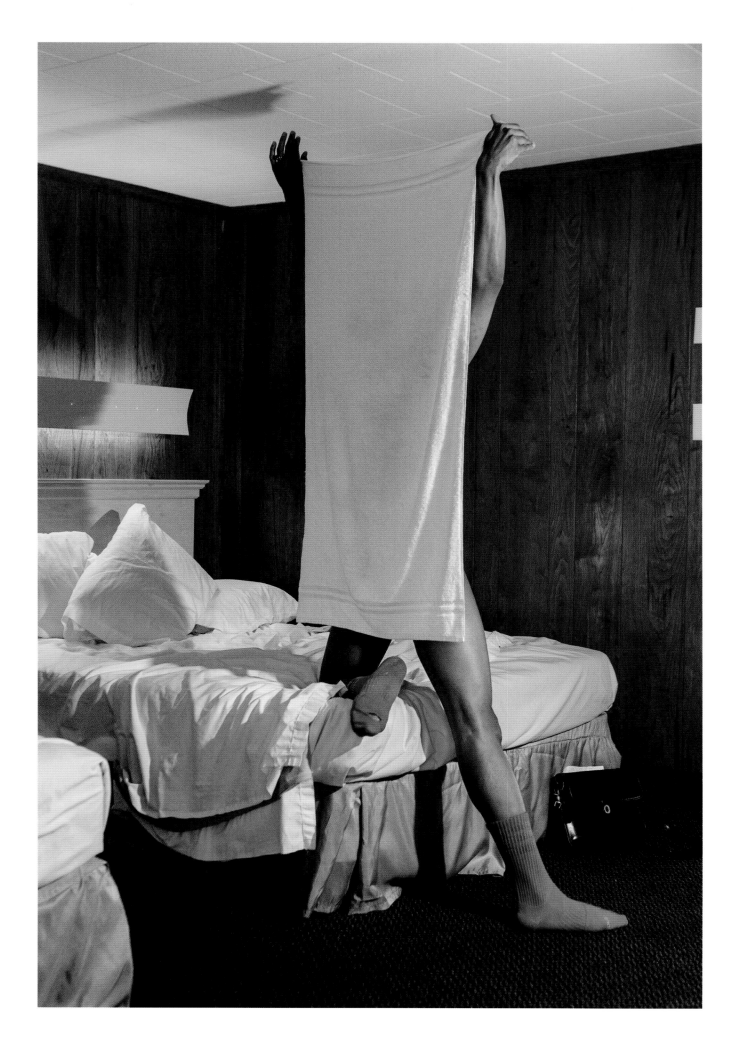

This mixed-media work by Jamaican artist Ebony G. Patterson is part of a series that challenges and scrutinizes the contradictory evolution of masculine presentation and representation in deeply homophobic Jamaican culture. Patterson presents this disciple of the church of skin bleaching, calmly returning the viewer's gaze. He embodies seemingly dissonant Jamaican masculinities. The subject's whitened face with bright red lips is haloed by flowers and golden doilies. A profusion of fish—slang for homosexual men—and butterflies float in the red, Baroque-inspired background, while smaller fish gather rather intriguingly on his neck. The dramatic contrast between his brown neck and stark white face represents a bombastic act of self-destruction, self-actualization, and, perhaps surprisingly, self-care. His appearance is an affront to dearly held, and somewhat-believed, Jamaican middle-class utterances like "Black is beautiful" and "Love the skin you're in." Jamaica's colonial legacies perpetuate the disenfranchisement of the subject's entire demographic; the truly empowered *always* seem to be of a lighter complexion. And he is rejecting the beliefs that don't serve him. His body is the one uncontested thing he can control, and he alters his appearance as an act of rebellion, as well as one of belonging—his bleached skin a visible symbol of belonging within his disenfranchised community.

—*O'Neil Lawrence*

Ebony G. Patterson
Untitled (Red), 2009; from the series *Disciplez*

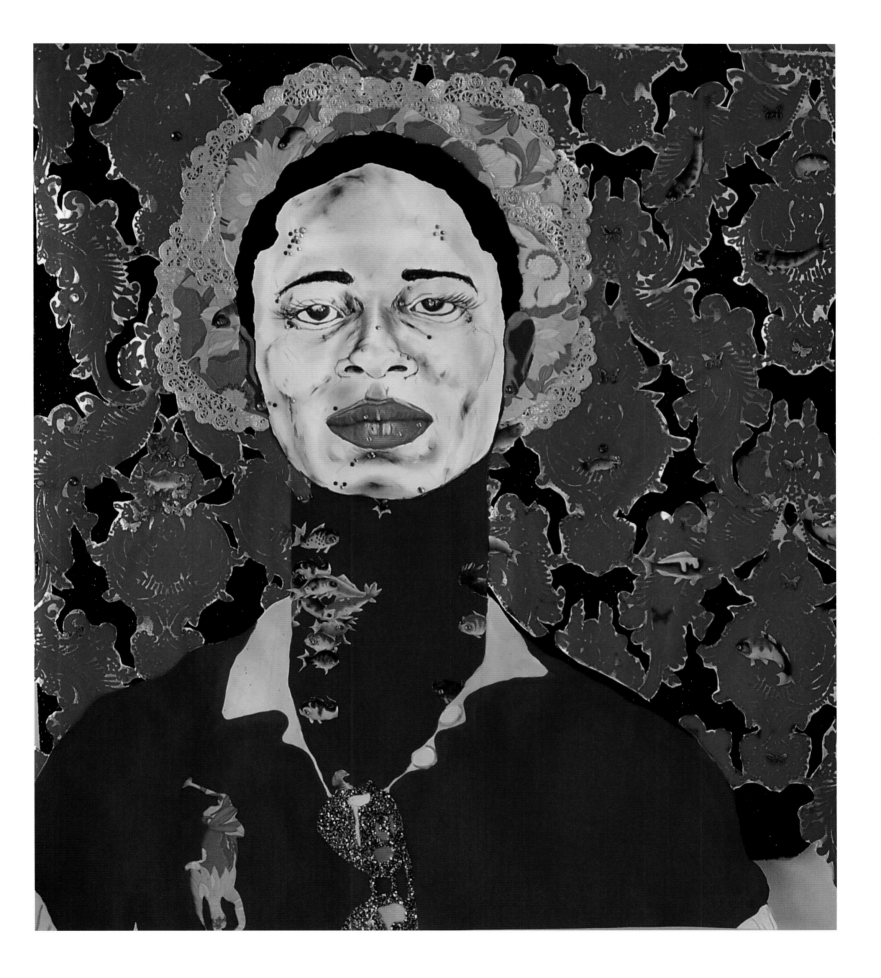

Identity

Eve Tagny
Gesture for a Petasites
Japonicus, 2020

Gesture for Fossil, 2020

Dawit L. Petros
Proposition 2, Mountain, Badwater, Death Valley, California, 2007. Temporary sculptural installation

133

Photography has historically been a tool of power. Countries of empire used the camera as a surveying device to promote the stockpile of territories and people that made up their conquests. From the early days of salted paper and albumen prints of British soldiers proudly showcasing their looted wares of elephant tusks and Benin Bronzes, images have acted as proof of reign over nations—a hungry energy active on the page.

Power appears differently in these pages and in the Wedge Collection. For the subjects and lineages of dominated countries, control is not motivated by an insatiable consumptive desire for land or culture; it is simply an embrace of the inherent free will of the self. The driving force is one of love. For African people and those of the diaspora, histories of domination meant that lessons of fundamental self-worth and embedded knowledge required concealment—a quiet vibration that is visible throughout the photographs.

Like the hungry energy thrumming through images of empire, images of Black folks created by Black folks come alive with a unique pulse. It is impossible to categorize a particular look, composition, or style that makes this empowered content visible, but it is known and felt. In her book *Listening to Images* (2017), scholar Tina Campt identifies this tension as "stasis"—an invisible motion or vibration that holds a sense of balance. Whether it be the defiant expression on a young woman's face in a Liz Johnson Artur portrait (page 151), a Nigerian woman's profile with plaited crown in a photograph by J. D. 'Okhai Ojeikere (page 142), or a still from one of Athi-Patra Ruga's contemporary Afrofuturist performances (page 154), these images all hold a stasis—one that calmly pronounces that the subjects inherently carry more self-determination than originally perceived.

Turning away from the camera can appear as a refusal of wanting to be seen. In these images, that is not the case. Photographs by Renée Mathews (page 152) and Kris Graves (page 153) present the fabric-adorned and dreadlocked backs of heads rich with textural detail. The depth in the hues, tones, and sheens welcome the viewer to spend time with these symbols of beauty, style, and Blackness.

Famed artist Jean-Michel Basquiat sits forward on a throne-like, high-backed chair with a Siamese cat on his lap (page 149). His laissez-faire lean and gaze away from photographer James Van Der Zee breathe a depth of grace that comes only from the inherent knowledge of history—that one carries kings and queens, obas and ayabas in their genes, which four hundred years of subjugation could not eradicate. Neither did generations of oppression stop Darnella Frazier—a teenage girl who conjured up the deep-rooted, intrinsic power of the camera to record George Floyd's murder by Minneapolis police, an act of courageous love that brought justice to Floyd's life in the process.

In a collection that prioritizes agency over the machinations of supremacy, we are witness to the lessons passed through lineages of perseverance. These pages reverberate with the foundational dignity and honor that help build futures we have only dreamed of.
—*Liz Ikiriko*

Power

Richard Mark Rawlins
Empowerment, 2018; from
the series *I AM SUGAR*

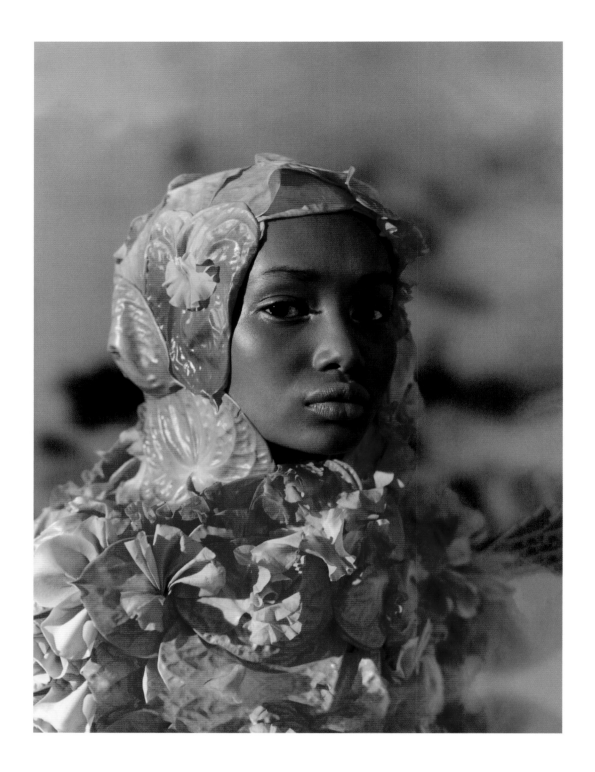

Tyler Mitchell
Untitled (Hijab Couture),
2019

Jamal Nxedlana
FAKA Portrait,
2019

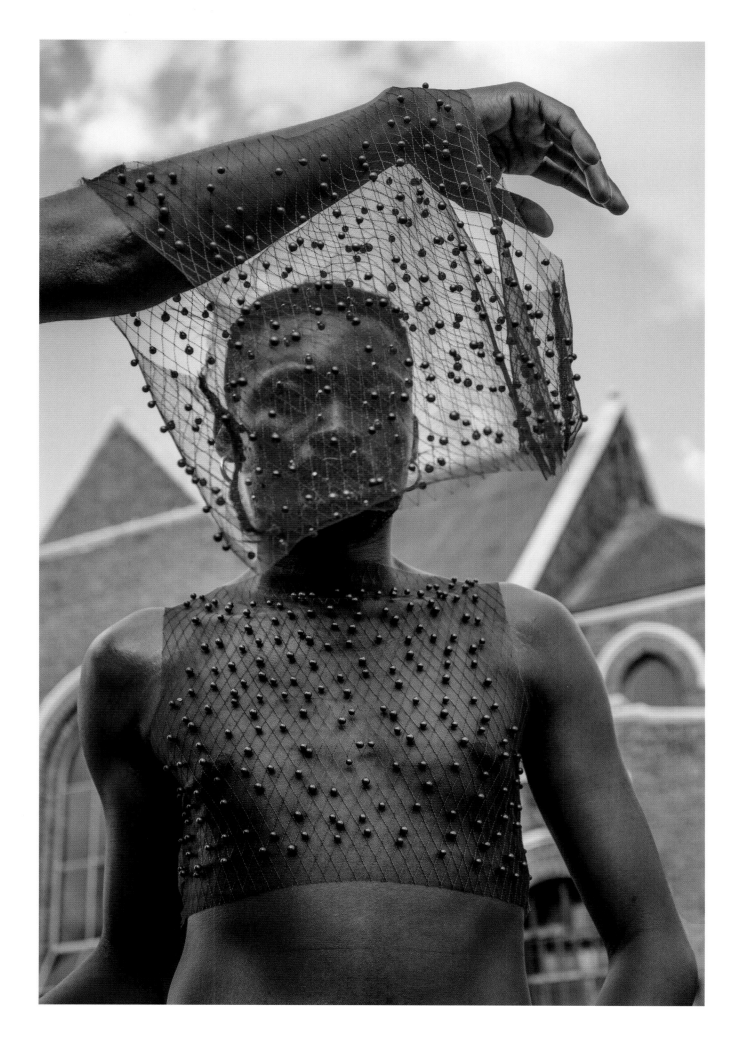

Jorian Charlton
Untitled, 2021

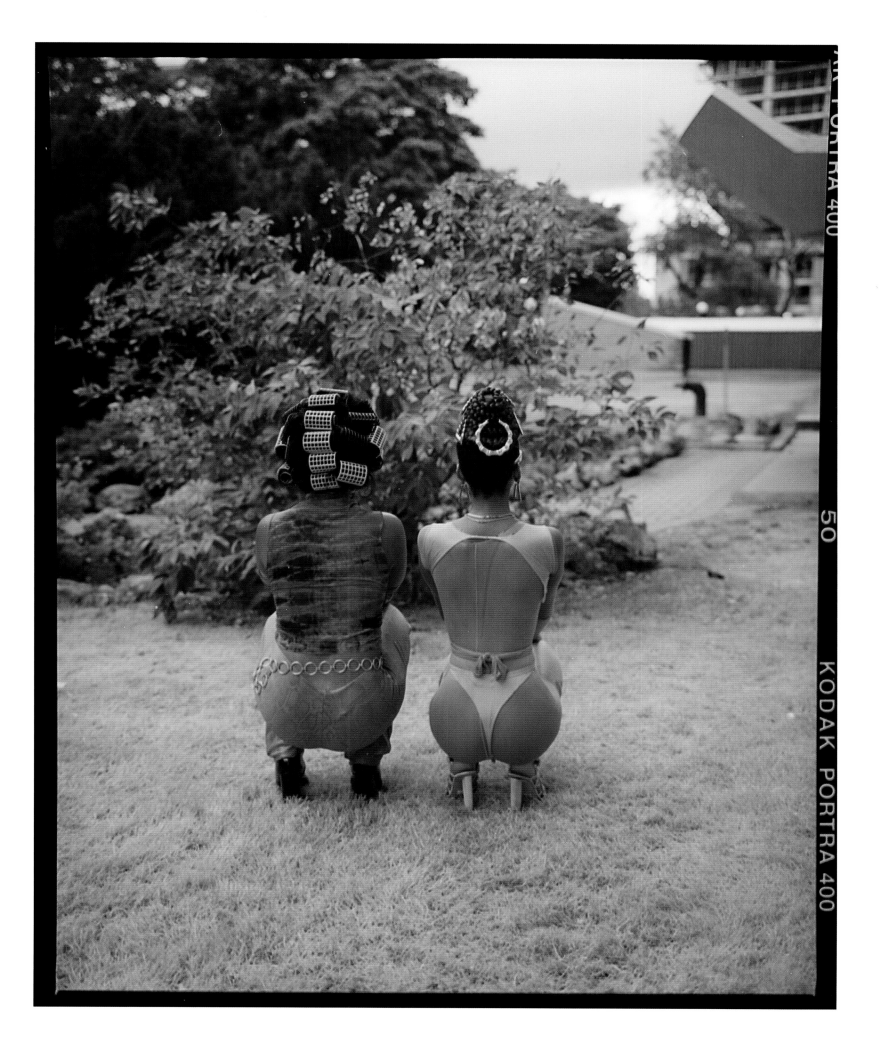

J. D. 'Okhai Ojeikere
Untitled (Aja Nloso Family),
1974

Untitled (Mikpuk Eba), 1974

"All these hairstyles are ephemeral. I want my photographs to be noteworthy traces of them," J. D. 'Okhai Ojeikere once remarked. In 1968, the Nigerian pioneer documentary photographer began his landmark *Hairstyles* series to document and preserve Nigeria's rich hairstyle traditions. Indigenous hairstyle practices had faced a marauding onslaught from colonial modernity and its Eurocentric beauty regime. They reemerged during the wave of cultural nationalism that followed Nigeria's independence from Britain in 1960. Over a decade, Ojeikere created an impressive portfolio of a thousand black-and-white images and twenty thousand negatives. Although he began the series in the vein of "salvage anthropology," recording the hairstyle traditions of Nigeria for posterity, he soon discovered that, like every other aspect of culture, these were evolving and ever-attuned to societal changes.

The regal *mikpuk eba*, arranged as buns, was traditionally worn during a maiden's coming-of-age ceremony by the Ibibio people of southeastern Nigeria. In contrast, the breathtaking *aja nloso*, a complex braid achieved with a vast number of attachments, produced the confident modern woman, a fixture of high society. Both hairstyles (depicted here) were not only statements of beauty, culture, or tradition; they also attested to women's power of self-fashioning and public display, as Ojeikere discovered. Traveling around Nigeria, he scoured city streets, social gatherings, and villages for models, and to capture elaborate coiffures. Collaborating with stylists, Ojeikere placed his sitters against neutral backgrounds, photographing the back or profile that produced a sculptural composition of the hairstyles. In the context of early postcolonial Nigeria, the vast complex of intricate hairstyles mirrored modernist demands of cultural revivalism and the liberated spirit of that era.
—*Ugochukwu-Smooth C. Nzewi*

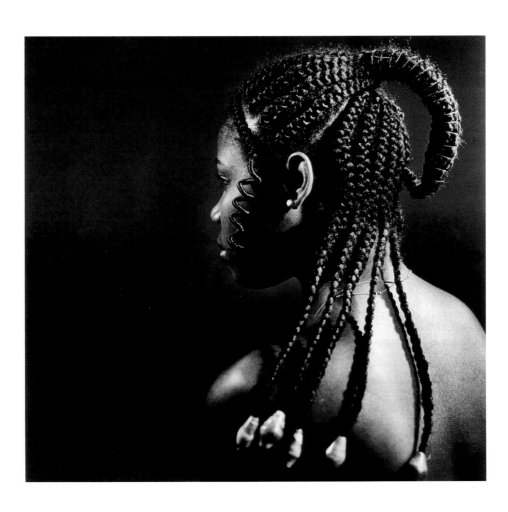

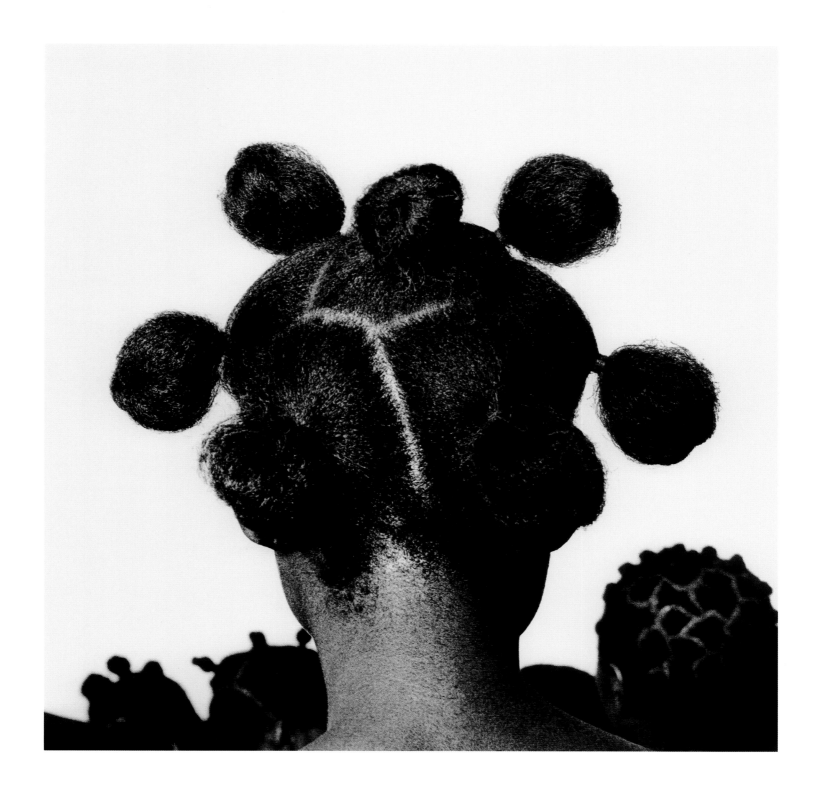

Autoportrait (1989–90) is Joy Gregory's three-by-three grid response to a deeply felt call for self-representation. Having come of age when mainstream fashion magazines and advertising media alike were unrepentant in their institutionally exclusionary position to not showcase Black models (often relying on the flawed economic argument that Black faces were less saleable), Gregory art-directed herself as a subject captured from multiple angles. The resulting concept evokes a fashion editorial contact sheet.

The images were created at the invitation of Sunil Gupta, cofounder of the Association of Black Photographers (now Autograph ABP) for the 1990 group exhibition *Autoportraits*, which Gupta cocurated with Monika Baker at Camera Work, London. Gregory was, in part, inspired by a conversation with American photo-historian Deborah Willis; she'd felt empowered thereafter to make self-portraits on her own terms. The nine original prints were made in an edition of one, printed on a special double-weight matte paper, which had been discontinued the year prior. Gregory painstakingly hand-developed the film to achieve the crisp expanses of white, and the absolute inky depths of hair, clothing, and eyes, in contrast with the warm, near-sepia mid-tones of skin and accessories. In 2006, Gregory recreated the work in an edition of twenty, using the original developing technique and materials she had retained for sixteen years.

—*Zoé Whitley*

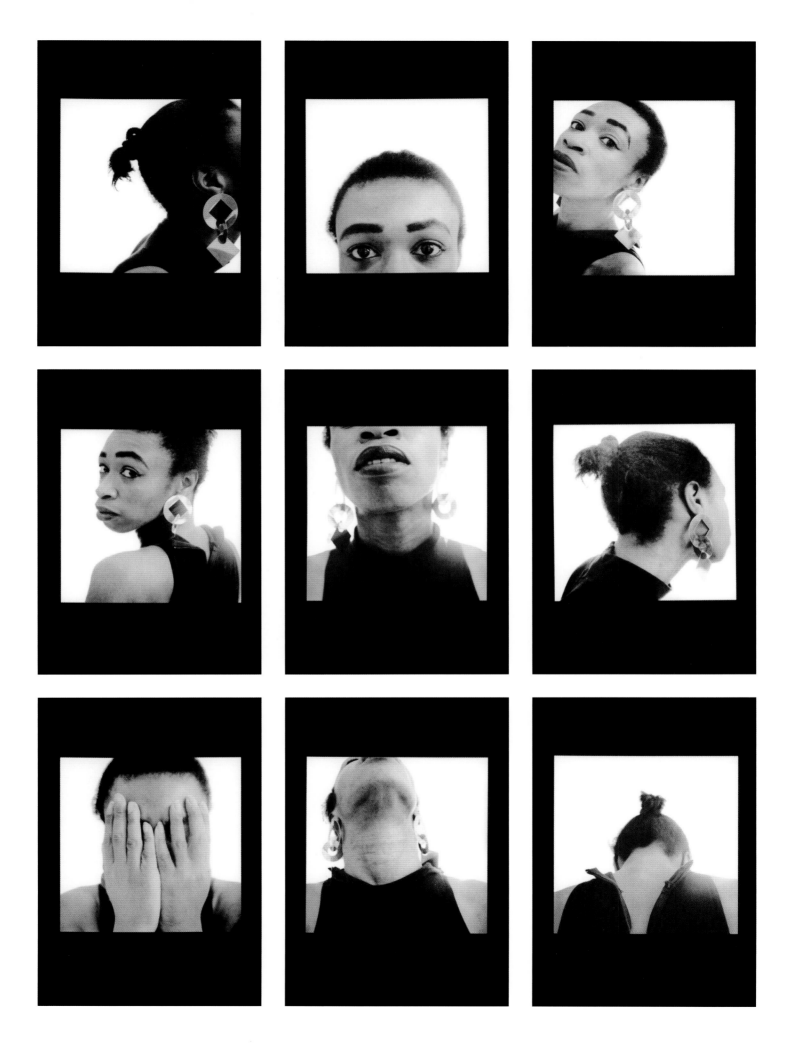

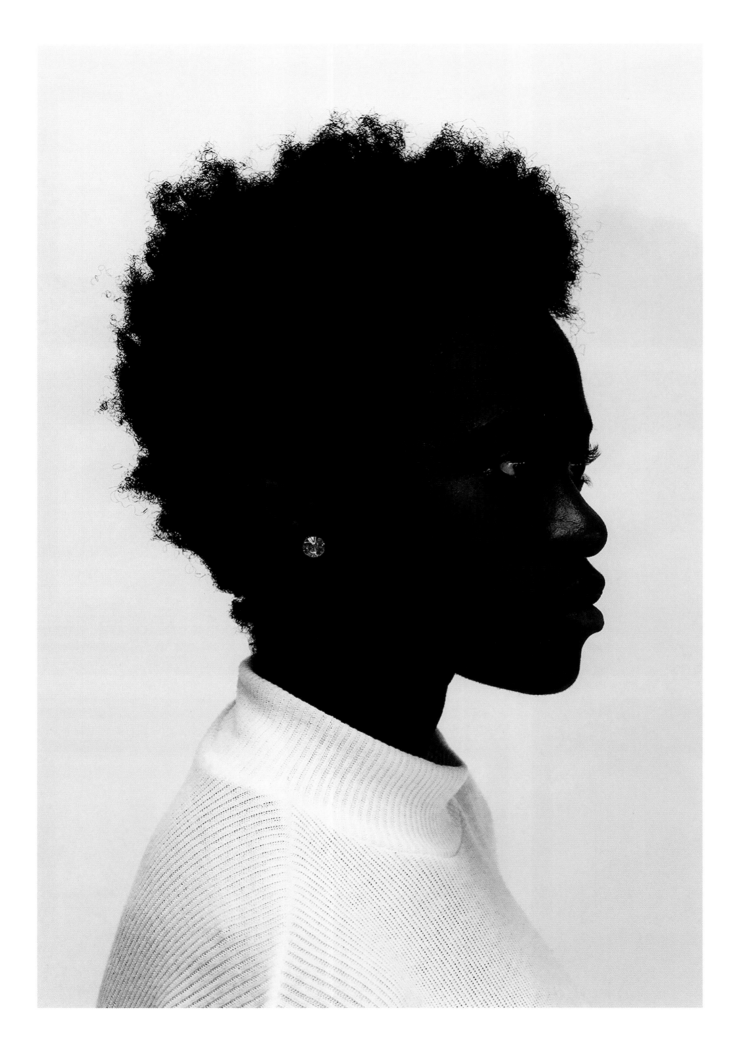

Yannis Davy Guibinga
Opposition, 2016

Leaves, 2016

James Van Der Zee
Jean-Michel Basquiat, 1982

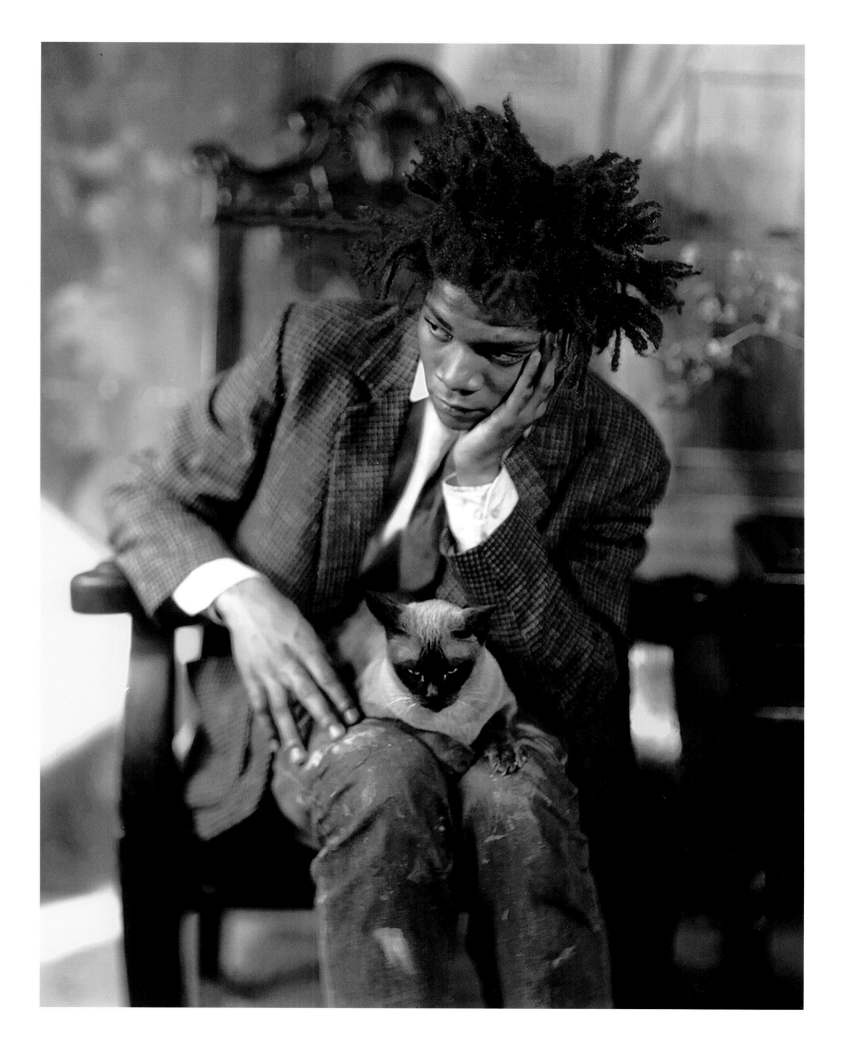

Anthony Barboza
Pat Evans, 1971

Liz Johnson Artur
Burgess Park, 2010

What artists decide to conceal is often just as important as what they reveal. Concealing can reflect a personal ethos of keeping something back for ourselves, a gesture of both agency and inner strength. Anthony Barboza, a founding member of the celebrated Kamoinge Workshop, evokes the power of Black style and presents a portrait of resilience in his remarkable photo of model Pat Evans in side profile (below). For New York–based Kris Graves, the back of the head is the main focus in *The Artist* (2015; page 153), representing a potent strategy in reconsidering the traditional portrait. Canadian artist Renée Mathews deconstructs a pair of old jeans and refashions their denim threads into a headdress that has a majestic quality to it (page 152). And while London-based photographer Liz Johnson Artur doesn't conceal her subject's face in *Burgess Park* (2010, right) the magic of her image lies in the subject's glance: she resists the traditional gaze at the camera with an expression that can't easily be defined, only adding to the picture's allure.
—*Kenneth Montague*

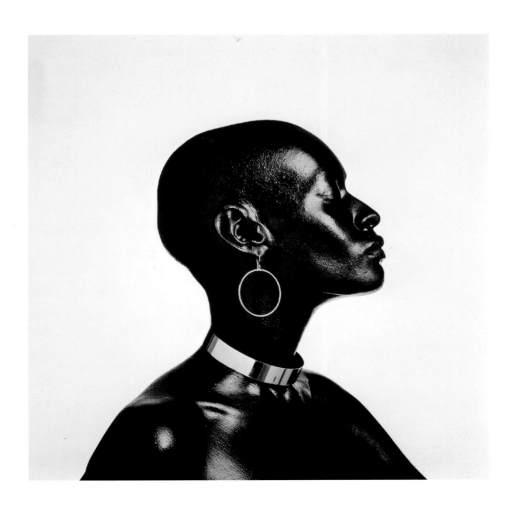

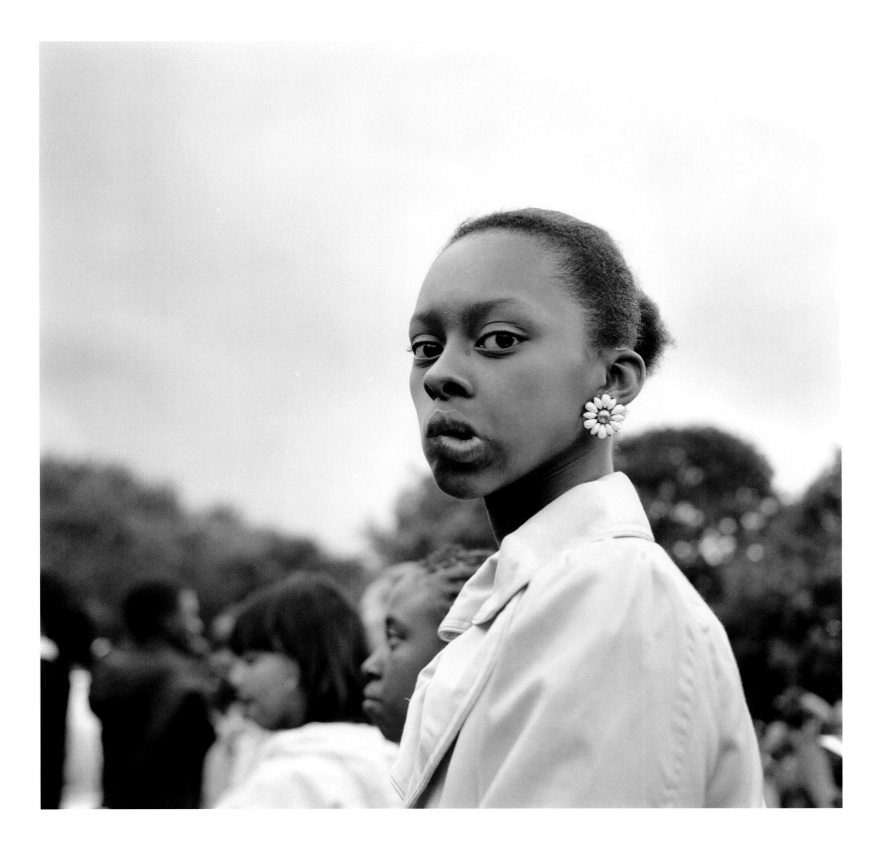

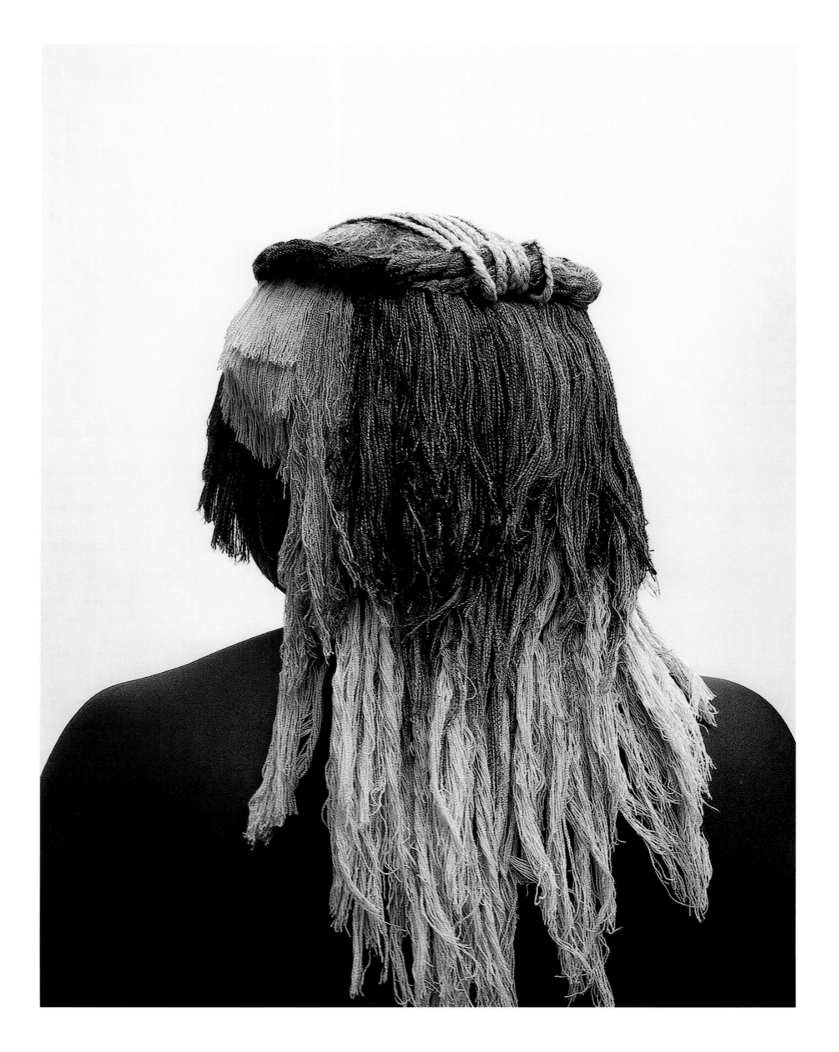

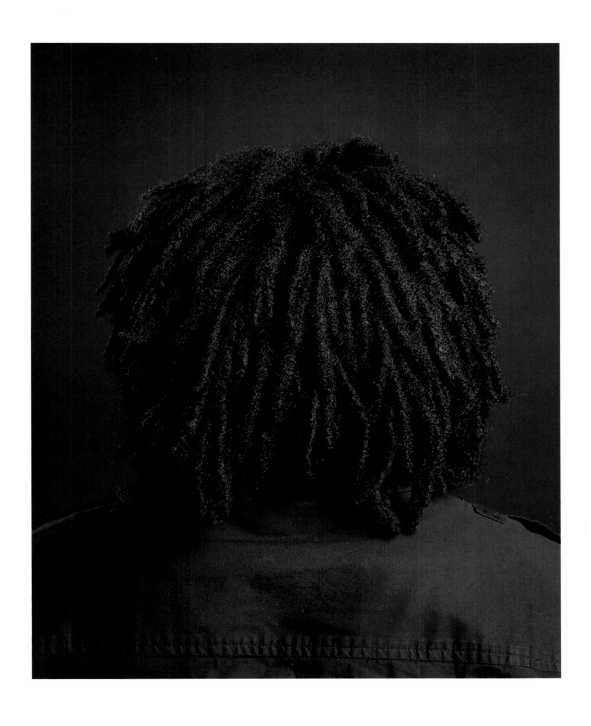

Renée Mathews
DW3, 2018

Kris Graves
The Artist, 2015

Athi-Patra Ruga
The Naivety of Beiruth 1,
2007

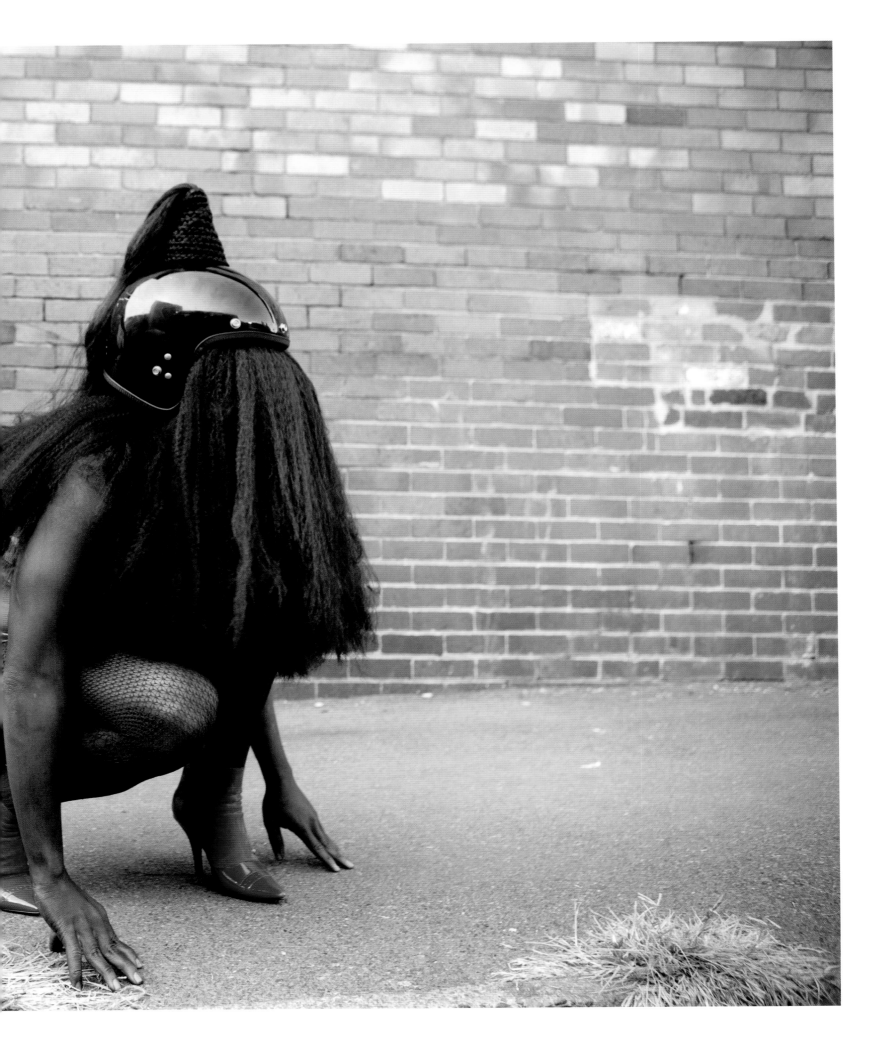

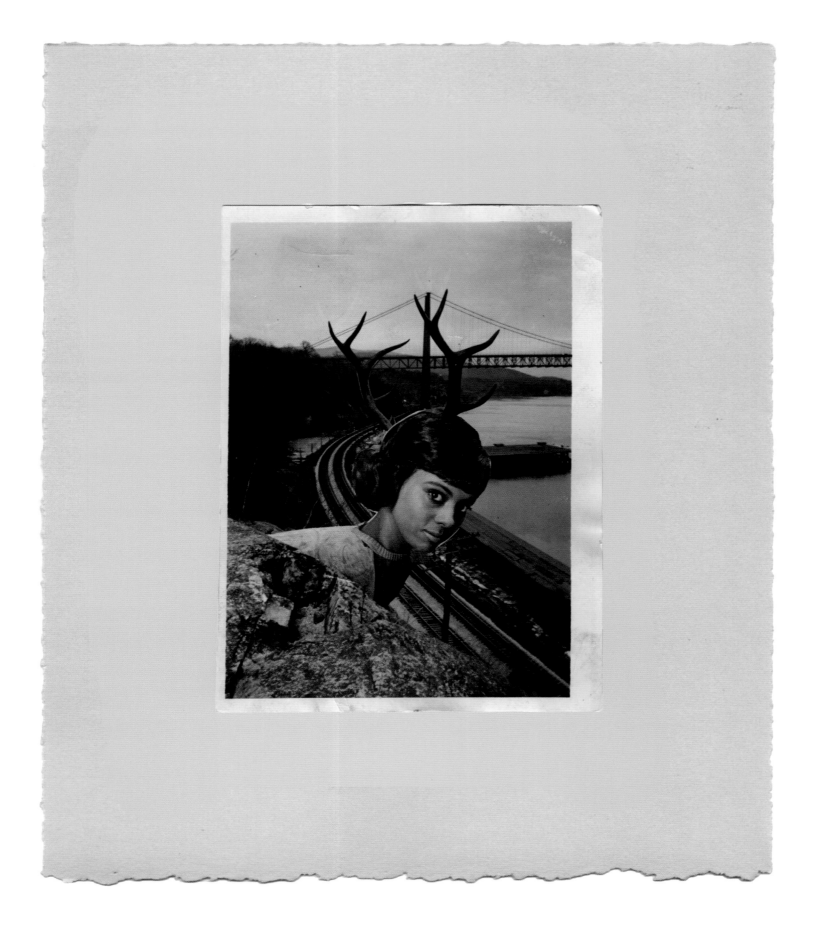

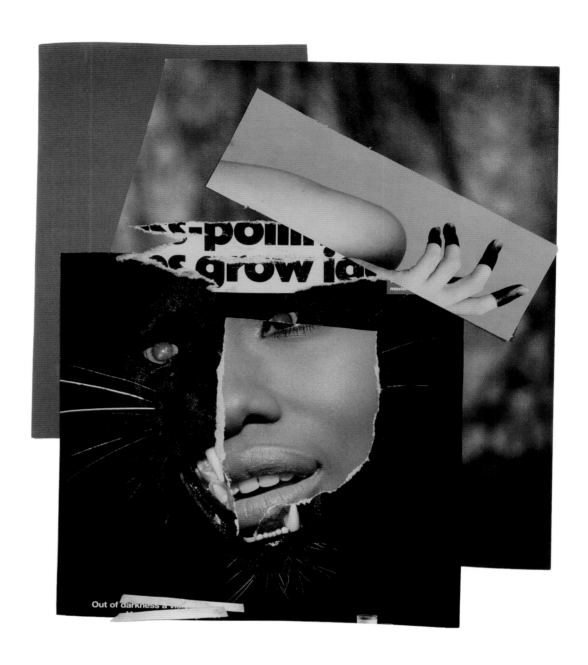

Lorna Simpson
Cliff, 2016.
Editioned print for the
Camden Arts Centre, London

Aaron Jones
Grow, 2016

Mickalene Thomas
Afro Goddess with Hand
Between Legs, 2006

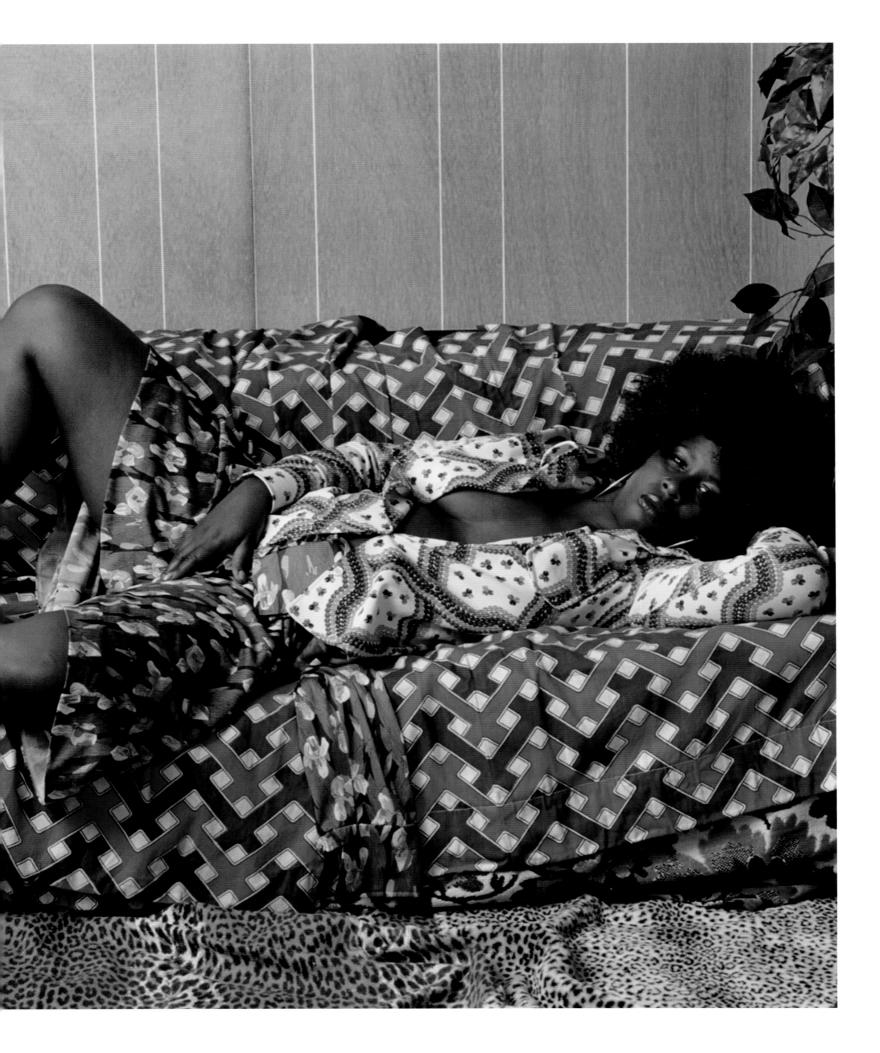

Ricky Weaver
My First Mind Tells Me,
2021

Rashid Johnson
The Reader, 2008

Hassan Hajjaj
Nido Bouchra, 2000/1421
(Gregorian/Hijri)

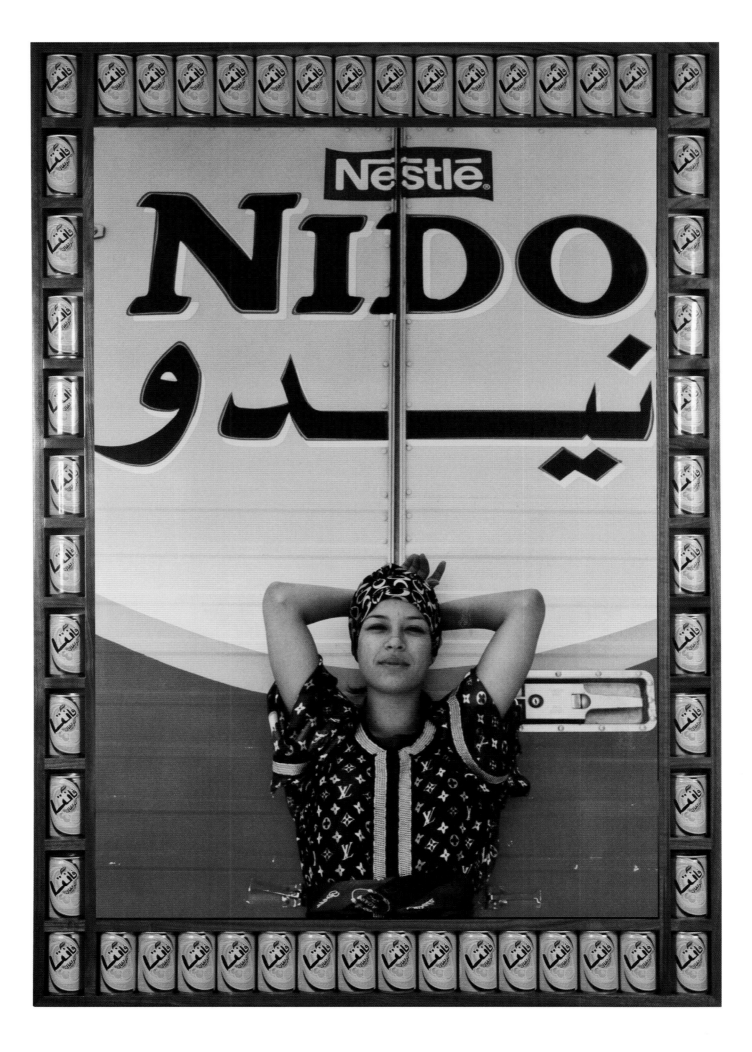

Light coloured short coat with a red cape
Waistcoat and breeches

**Camal Pirbhai and
Camille Turner**
Lowcanes, 2011–18;
from the series *Wanted*

Renee Cox
Red Coat, 2004; from
the series *Queen Nanny
of the Maroons*

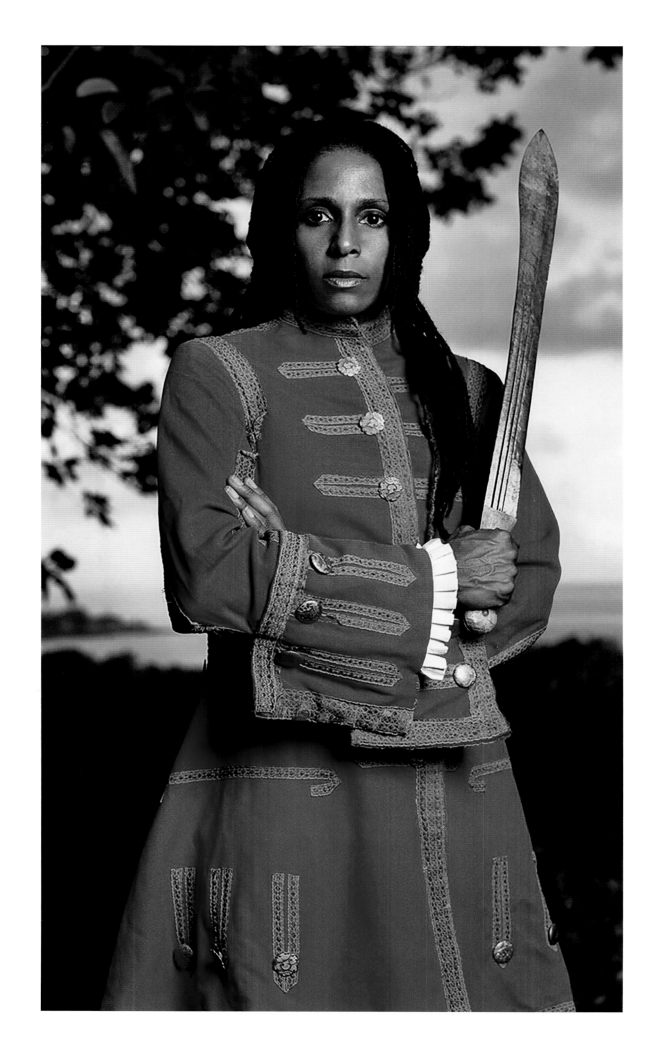

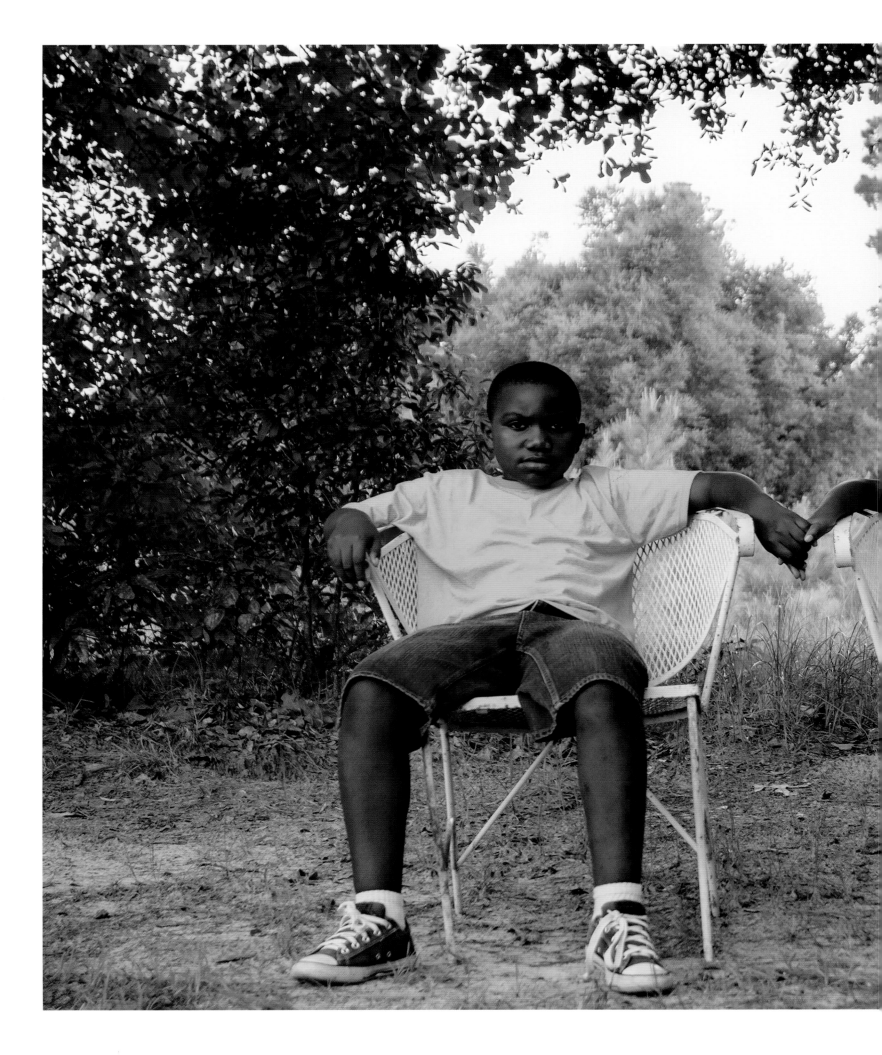

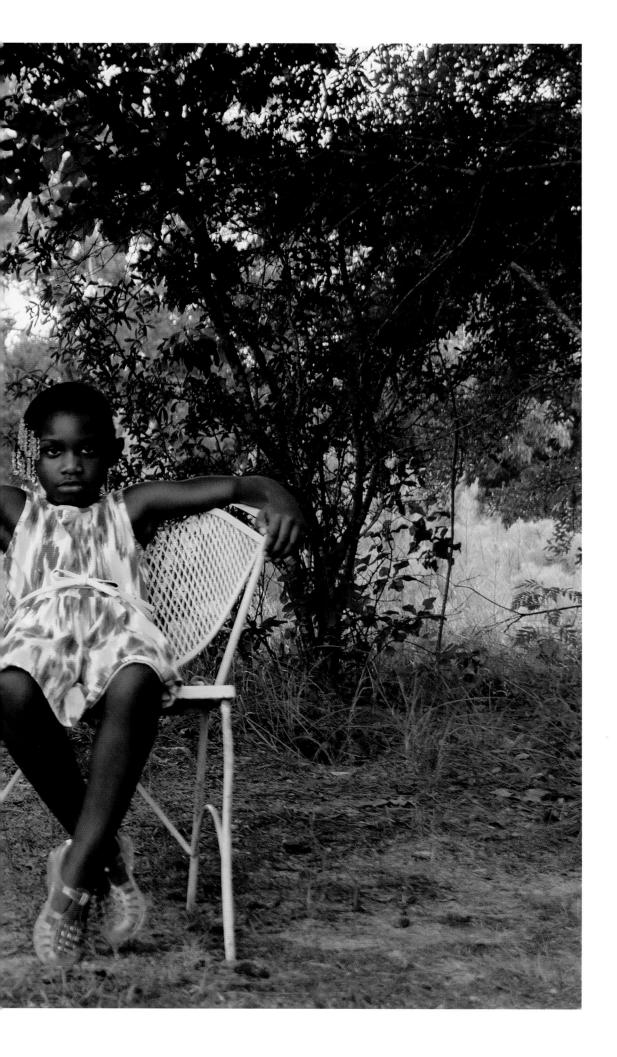

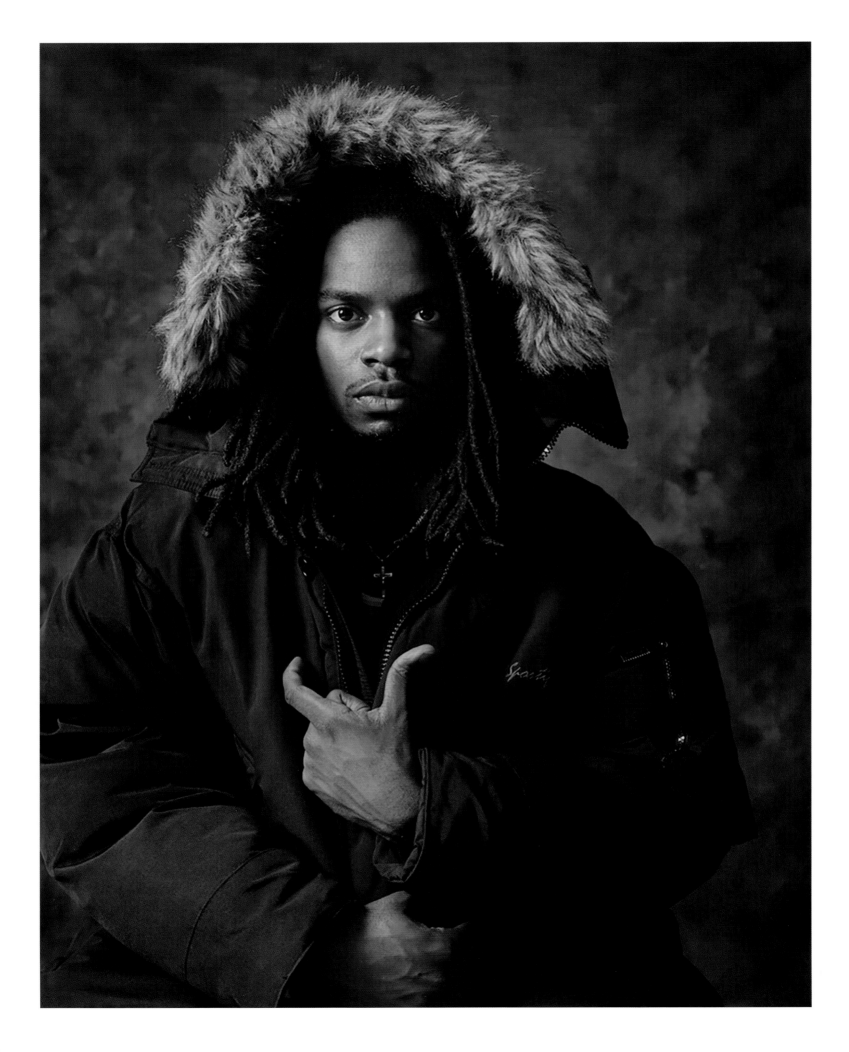

Dawit L. Petros uses a variety of gestural and compositional elements and conventions drawn from art history in his series *Transliteration* (2003). He nods to the so-called Old "Masters"—such as Rembrandt, Albrecht Dürer, and others in the Western European canon—by interposing young Black men, as well as using a range of influences and signifiers from art history, theater, hip-hop, and film. In so doing, he remixes and recontextualizes the sociocultural and historic codes in which the original work was set. *Sign* (2003), a large-scale color photograph, gestures to Dürer's *Self-Portrait at Twenty-Eight* (1500), in which the artist seems to position himself as a mystical Christ-like figure. Petros's Black male subject is attired in a style associated with "urban," "street," or hip-hop culture. His hands form an enigmatic gesture or sign, which allows for myriad interpretations, while also highlighting the photograph's overall ambiguity; it defies easy translation. Petros uses photography—and by extension, portraiture—to decenter the histories of Western art and make space for a retranslation of Black bodies into contemporary art.

—*Julie Crooks*

Dawit L. Petros
Sign, 2003

Kehinde Wiley
After Sir Joshua Reynolds'
"Portrait of Doctor Samuel
Johnson," 2009

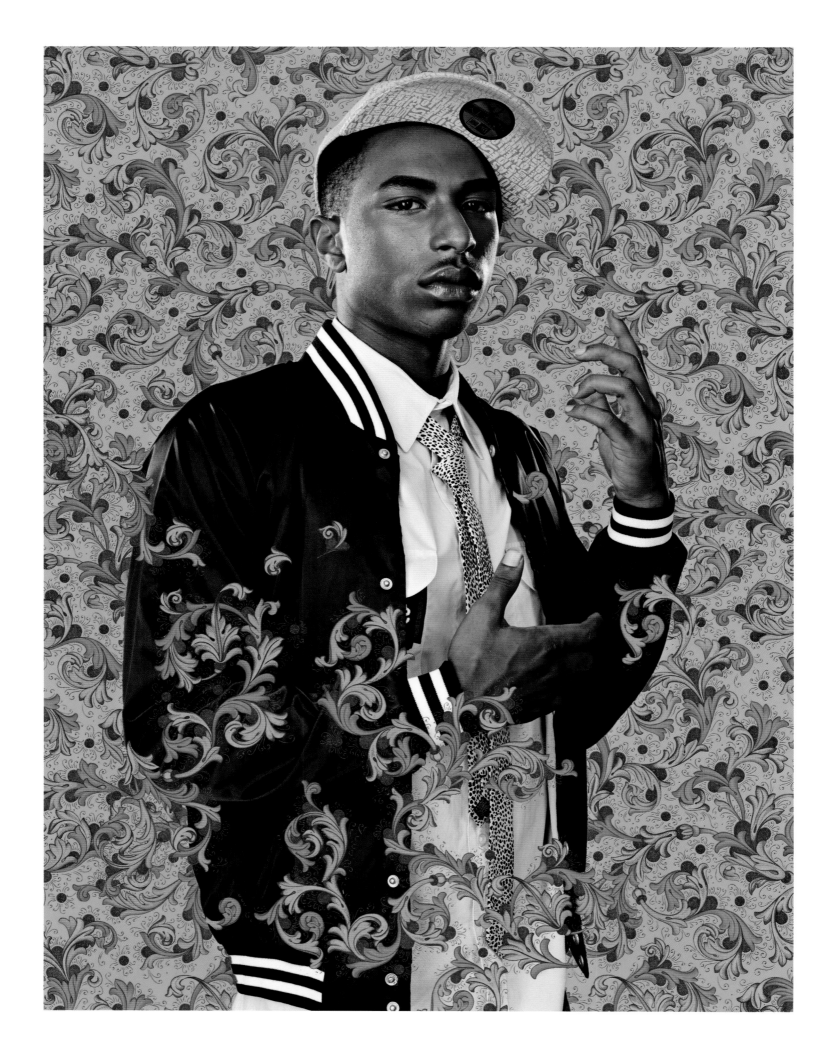

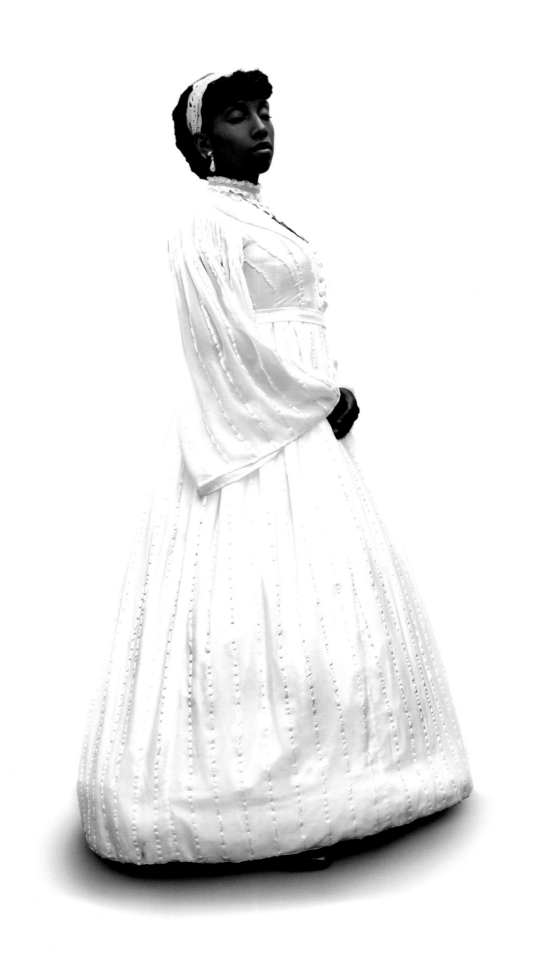

Ayana V. Jackson
Sarah, 2016

Stella, 2016

Deeply reflecting on her identity, Ayana V. Jackson began to use her own body as an essential strategy for storytelling, examining the photographic construction of race and gender. Jackson's 2016 series *Dear Sarah* was inspired by the story of Sarah Forbes Bonetta, an African woman of Yoruba origin presented as a gift to Queen Victoria by King Ghezo of Dahomey—a precolonial African kingdom located in present-day Benin. Jackson reconstructs the narrative, positioning Sarah not as the property of monarchs, but rather as a young woman of royal lineage and privilege in nineteenth-century England. Works from *Dear Sarah* are printed on silk polyester, and the natural currents in the air make the life-sized figures feel like they're actually dancing. When I first saw the pieces installed, they took my breath away.
—*Kenneth Montague*

Bidemi Oloyede
Jah Grey, 2019
Zoë Edwards, 2019
Joanna Okoh, 2018

Bidemi Oloyede makes tintype portraits—one
of the oldest photographic technologies, in
which the image is printed onto a thin metal
sheet coated with a special emulsion. The
process produces a unique positive image that
cannot be reproduced, lending itself to deeper
reflections about its uncanny suitability as a sin-
gular photo-object for a range of Black subjects.
By using a nineteenth-century process to depict
contemporary African Canadians, Oloyede takes
a multi-temporal approach, intersecting across
time, space, and geographies. It's an ongoing
project that sets out to capture today's African
Canadian communities as part of his ongoing
BL/ARCHIVE series. Oloyede references and
repurposes the weight of history vis-à-vis the
ways the medium has been used against Black
subjects, who were often pathologized or depicted
as specimens rather than human beings partici-
pating in a portrait. Oloyede's sitters, in contrast,
look back at the viewer with self-possession,
completely at ease with the encounter. The special
attributes of the tintype, with its variant tones
of brown and gray on the metal, are further
enhanced by studio lighting that enriches the
sitters' natural skin tones.
—*Julie Crooks*

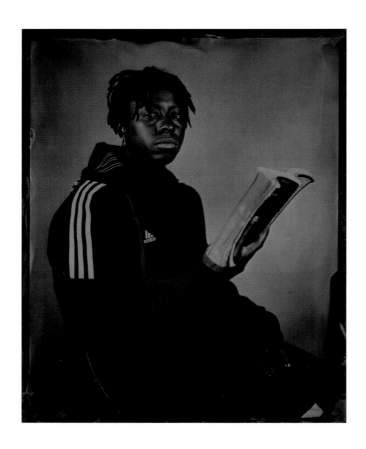

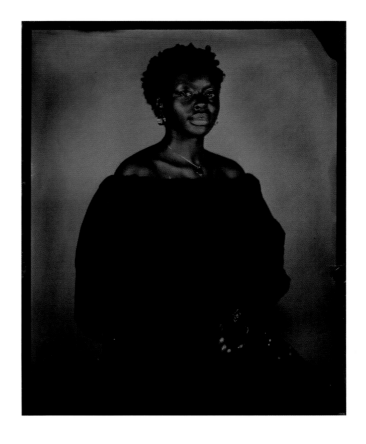

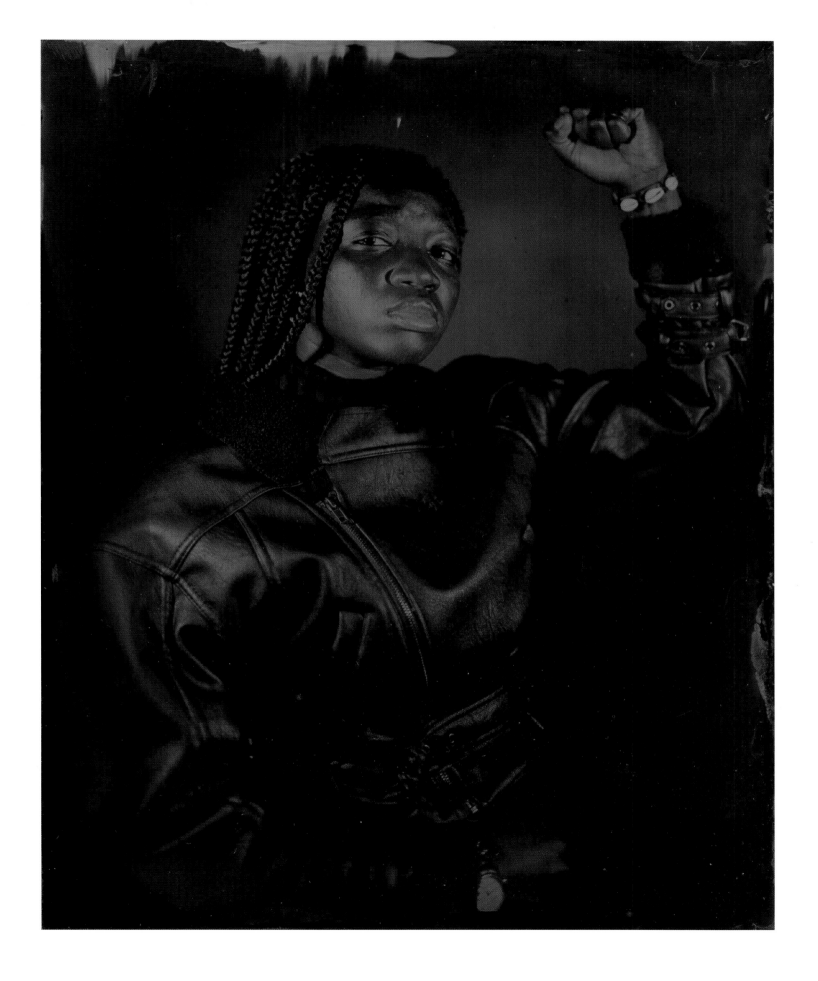

Raised in Scarborough (a suburb just east of Toronto), Jalani Morgan is best known for his deep commitment to picturing the changing social and cultural landscape of the city. *Black Lives They Matter Here* (2014) depicts the first public gathering of Toronto's Black Lives Matter chapter, protesting the death of New Yorker Eric Garner at the hands of police, who were never indicted for his murder in spite of clear visual evidence. Black Lives Matter Canada works to "actively dismantle all forms of anti-Black racism, liberate Blackness, support Black healing, affirm Black existence, and create freedom to love and self-determine," and Morgan took part in both this protest and its documentation; his bird's-eye view enhances the powerful gesture of unity. In 2017, a large-scale public installation of this image was on display with Morgan's series *The Sum of All Parts* in downtown Toronto. It was vandalized in a blatant display of racism—a reminder that we still have a long road ahead.
 —*Kenneth Montague*

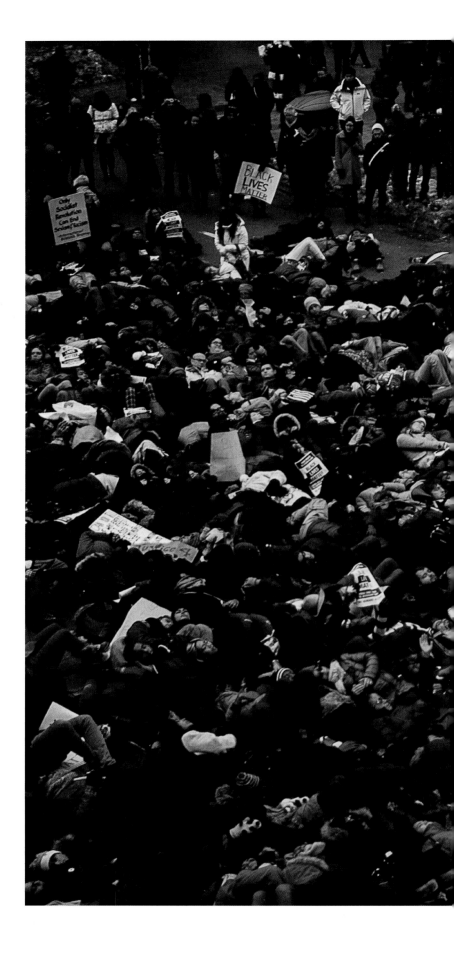

Jalani Morgan
Black Lives They Matter Here,
2014

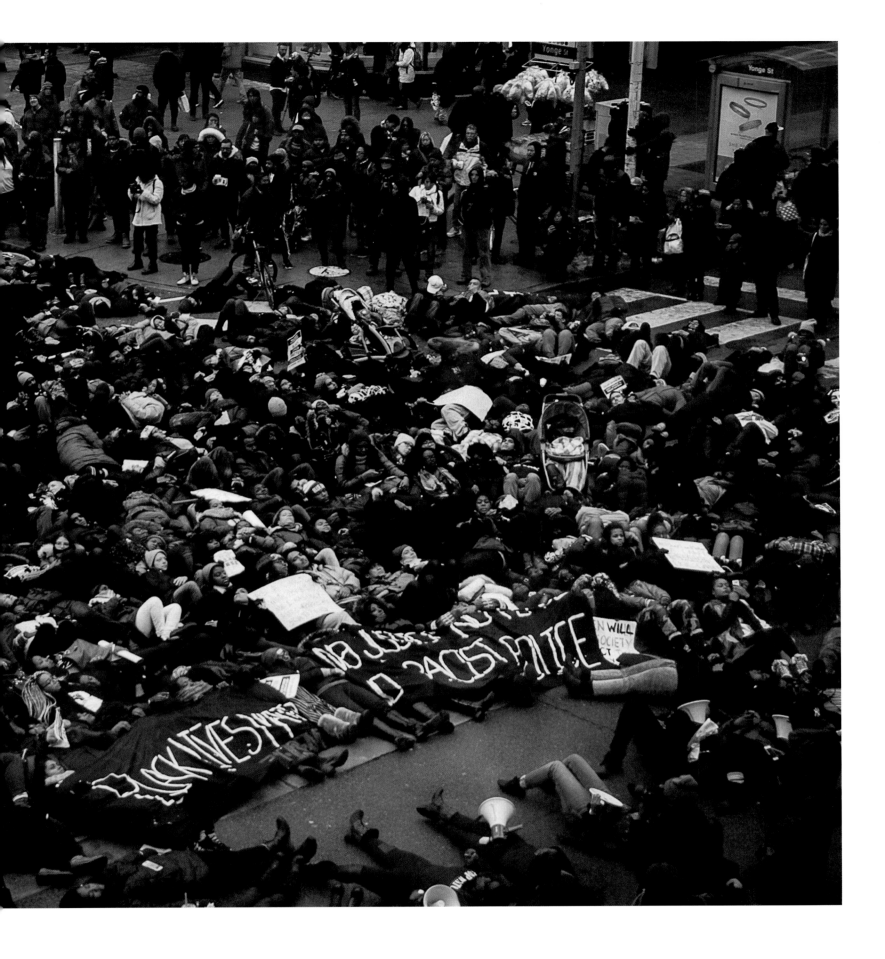

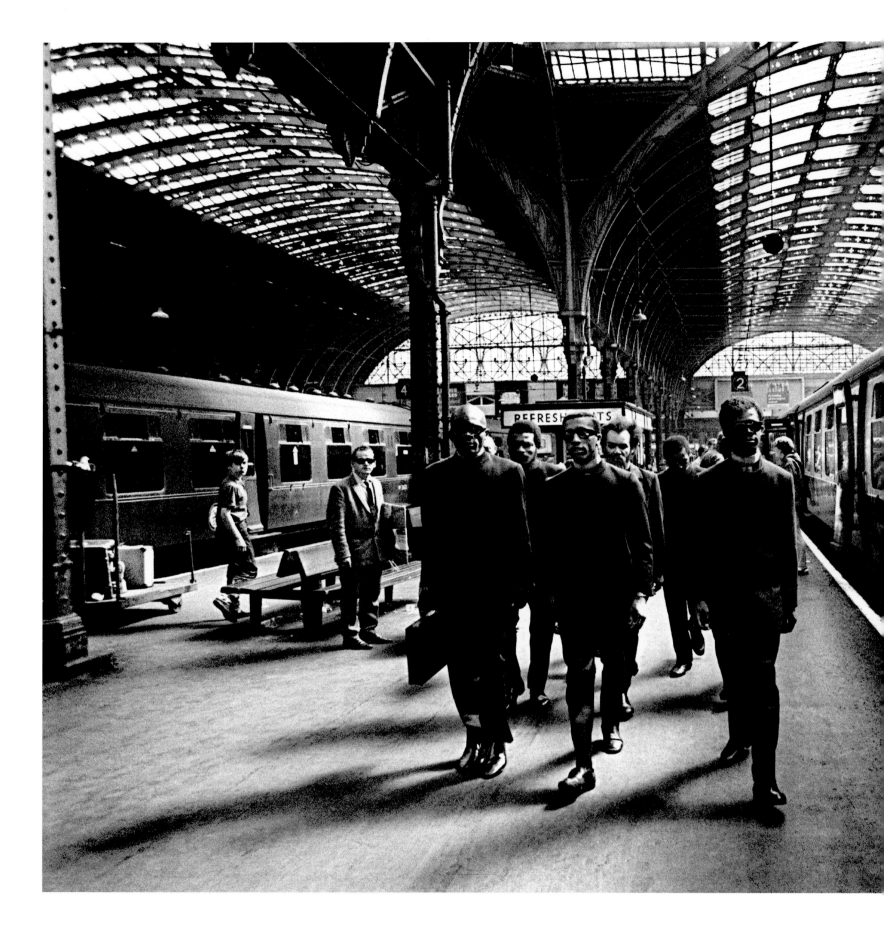

Power

"Train yourself to see." This is the advice Horace Ové has followed throughout his esteemed career as a filmmaker and photographer. Ové brought his filmmaker's sensibility to capturing this dramatic scene as Michael X, a prominent leader of the Black Power movement in the UK, arrived at London's Paddington Station—framed by train cars on either side and with the Victorian vaulted glass ceiling hovering above the grand terminus of the Great Western Railway. White onlookers stand frozen, in awe of the procession of Michael X flanked by bodyguards.

Both Michael X (born Michael de Freitas) and Horace Ové grew up in Trinidad and were known to one another. Greatly influenced by Stokely Carmichael's (later Kwame Ture) calls for Black Power, Michael had taken on "X" as his surname after reportedly being mistaken for Malcolm X's brother. As adults, both Ové and Michael X found themselves in London. A mutual friend and member of Michael X's entourage tipped off Ové that Michael X would be on this train, allowing Ové to be optimally positioned to take this era-defining photograph at the crossroads of Britain's industrial past and multicultural future.

Ové's image captures a powerful and triumphant moment in Black activist iconography, but it also signals the threat to the status quo posed by Black radicalism. Not long after this photograph was made, Michael X was arrested on charges of inciting racial hatred. Ironically, he was the first nonwhite person to be prosecuted under the terms of the Race Relations Act 1965, which had been enacted to protect Britain's Black and Asian communities from violence born of bigotry. High-profile individuals such as Yoko Ono and John Lennon supported Michael X's cause of Black empowerment and stood by him, even as others distanced themselves thereafter.
—*Zoé Whitley*

Horace Ové

Michael X and Entourage in
Paddington Station, 1967

Setting the Scene

Interview with Wedge Collection
Founder Dr. Kenneth Montague

*Dr. Kenneth Montague, a Jamaican
Canadian collector and advocate
of Black contemporary art for the
past twenty-five years, is a practicing
dentist in Toronto, where he resides
with his wife and two sons. Friend and
curator Liz Ikiriko sat down with
Montague to discuss his motivations,
influences, and guiding principles.*

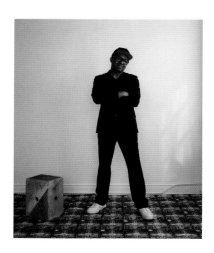

Liz Ikiriko
Kenneth Montague
in Toronto, 2017

Liz Ikiriko: Through the years, as a passionate art collector, you've developed many friendships and are now embedded in a global community of artists, curators, museum directors, and collectors. Have there been any particular people who have supported and guided you in your role as a collector?

Kenneth Montague: I am who I am because of the environment that I grew up in—in Windsor, Ontario, just across the river from Detroit. My parents were among the earliest immigrants from Jamaica to this region of Canada. Windsor is situated on an international border, and my upbringing was therefore a mix of Canadian and American experiences. A major challenge was sometimes feeling like an "island" growing up, largely because I was often the only Black kid in my school. Luckily, I had parents who encouraged viewing art that celebrated Black culture, and my mother took my siblings and me on day trips to the Art Gallery of Windsor or the Detroit Historical Society. It was during that time that I first saw *Couple in Raccoon Coats* [1932; page 78], a James Van Der Zee photograph of a well-dressed, well-to-do Black couple—something you didn't see on TV or in films—in an exhibition at the Detroit Institute of Arts. I recognized that there was another way that Black folks lived that wasn't being publicly portrayed. I really plugged into that idea from early on, and that was basically my introduction to art—seeing reflections of Black life that were representations of who I was and aspired to be. This helped shape my own identity.

My father's ethos was "lifting as we rise." As kids, my older brother and sister and I picked up this family motto through osmosis. Both my parents were amazing role models.

Another personal ethos came to me as a directive and a challenge from my friend, director and curator Thelma Golden of the Studio Museum in Harlem. In the early 2000s, Thelma said to me, "You've been taking the global and making it local for your Canadian audience. Ken, don't you think it's time for you to make the local global?" Her saying that became a real manifesto. That's exactly what I wanted to do, but I needed to hear it from someone like Thelma. Ultimately, this may be the biggest legacy of the Wedge Collection: the introduction to a global art world. To bring artists that I love and cherish, that mean so much to me as a collector here in Canada, and to strengthen the Black Canadian presence in the art world.

Ikiriko: In 1997, you founded the Wedge Collection, a body of artworks celebrating expressions of African and diasporic identity. You are also the director of the nonprofit organization Wedge Curatorial Projects, which exhibits the works of local Black artists and considers issues of race and representation. Can you describe how these two entities came to be?

Montague: The origin of the whole project was a wedge-shaped space that I used as a gallery in my home in 1997. The first show was set up like a Sunday afternoon salon—really DIY projects! A young Black dentist with no formal training or academic art history background becoming a collector and opening a public art space in his private residence was a radical act.

The Wedge Collection grew out of those original shows of work in my home, but it soon became clear that there were two streams evolving—this private collection and a curatorial not-for-profit. The Wedge Collection started to differentiate itself from the curatorial project as I accepted invitations to lend work from the collection to various institutions.

As a nonprofit, Wedge Curatorial Projects focused on funding bigger shows than those in my living room. Soon, we were working with emerging and established curators, and artists who had never before been granted solo shows in Toronto. It was a first for so many artists, including James Van Der Zee, Seydou Keïta, J. D. 'Okhai Ojeikere, Jamel Shabazz, Dennis Morris, and Dawit L. Petros.

Ikiriko: As Black Canadians, it's common for us to share stories of isolation as Black kids growing up across the country. I wonder if the formation of the Wedge Collection was a way of creating a sense of community to counter that feeling?

Montague: I grew up with a skewed view of my own community because of the isolation. Of course, there were many people who had come before me, and there were important stories that I was not learning in Canadian history class that I had to discover on my own. As I got older, I met many other people—like yourself—who experienced this growing up, this sense of being the only one. When you're a kid, you don't have the vocabulary or language, but now, I recognize a lot of trauma, from little microaggressions to full-out racism.

One way that I fought back was forming a punk reggae band called Contradance while in university. We released a record called *Black Preppies* that satirized the varsity look. The title song's chorus was: "I'm wasting all my money on my classic look, just so that I don't look like a common crook." That still resonates now. I was code-shifting to save my life.

I had to create a world of my own, and that is what manifests in the Wedge Collection. It was a way of engaging with the world that I had longed for. My search for self, in terms of identity and seeing many different aspects of Black identity, was created through various artworks and mediums, specifically photography.

Ikiriko: The main themes of *As We Rise* are community, identity, and power. As these themes are recurrent in the collection, can you speak to any Wedge Collection exhibitions that have been particularly archetypal?

Montague: The show I'm most proud of, that fulfilled my promise to focus on the local and make it global, was *Position As Desired: Exploring African Canadian Identity*, looking at

works in the Wedge Collection. It really started me on a journey. The first iteration at the Royal Ontario Museum was in 2010. The four artists in the initial catalogue were Christina Leslie, Megan Morgan, Dawit L. Petros, and Stacey Tyrell. As the show expanded and more artists were added, it toured to the Museum of Canadian Immigration at Pier 21 in Halifax, and then came home to the Art Gallery of Windsor. It was obvious that the show resonated with others. It was the biggest show they'd ever had at the Art Gallery of Windsor.

The largest show that we've produced to date was called *Becoming*. It was a perfect title for a show that was thinking about Stuart Hall's writing on representation and identity, and Blackness as a constant state of "being" and "becoming." It originated at the Museum of Contemporary Art Detroit in 2008, and was expanded for the Nasher Museum of Art [Duke University, Durham, North Carolina] in 2011. It moved through historical photographs in which the subject had no control over how they were being depicted, onto images where the photographer had increasing engagement with the subject, and works by Jamel Shabazz, among others, where there's an interplay between subject and photographer. It then moved onto images where the subject has complete agency and control over how they're being depicted, ending with Mickalene Thomas's *Afro Goddess with Hand Between Legs* (2006; page 159), where she is inhabiting a character or imagined state of being, in control of every aspect of the image.

It's interesting to think about the collection and to note how it's evolved over time; I have much greater interest in the many ways that photographers are choosing to portray their subjects now that also includes a wide array of self-portraiture.

Ikiriko: Having known you for about fifteen years, it's clear to me that maintaining good relationships with the artists whose work you collect is as important as sharing their work with the world. Can you speak to the importance of being a Black collector of Black artists' works?

Montague: I really feel like I have an impulse that might be a little different than other collectors. I have the "collecting" obsession of wanting to own something and have a longer relationship with it, but I see my difference in a deep desire to share the work. From the outset, my mandate was to "wedge" these lesser-known, underrepresented, and uncelebrated artists into the story of contemporary art and into the mainstream. For many artists, I may be their first collector or one of their earliest collectors. It gives the artists a boost for their portfolio and to their belief in their own art practice.

A particular point of pride for me was being a Black collector of Black artists' work at Documenta in Germany. I have a great memory of attending the 2007 edition, where I had planned on meeting J. D. 'Okhai Ojeikere, who was exhibiting his *Hairstyles* series (1968–80;

pages 142–43). I'd bought the work and shown it in 2002 in Toronto, and though there was phone communication between Ojeikere and myself, we had never met. I wrote to him and said that I would be at Documenta and I'd come to meet him. I remember not being able to find him in the crowd. I finally spotted him, and I'm walking toward him—he's in front of his booth. I was less than fifty feet in front of him, talking to him on my cell phone, waving and saying, "I'm right here. Can't you see me?" He's looking all around and finally, when I'm right in front of him, I say, "It's me, Kenneth Montague." And he replied, "Oh my God, you're Black! All this time. I didn't know that you're Black, and you're the collector of my work!" Suddenly, he was in tears.

That was one of those times as an art collector that I realized, again, that I was an island. It was a familiar feeling of, Okay . . . it's going to be like this. Even the artists were not expecting that I would be a Black collector, due to the forces of the art market.

Luckily, Black gallery directors, institutional leaders, and collectors have really ramped up in the last decade, and the last couple of years in particular, so that the occurrence is now far less rare. That feeling of always being an island is beginning to shed like a skin. Now, it's about helping to lift and rise. More than ever, there's a desire and a need for our voices. In fact, the need was always there, but now, these institutions can't turn a blind eye to us. The mission changes to how we can seize this moment and make sure that it isn't just a moment—make sure we keep our foot on the gas and keep going.

Ikiriko: As someone who has been collecting for twenty-five years, can you speak to the shifting views of Black representation and portraiture? Do you see a change in how Blackness has been presented, from the early days of photography with portraiture of Frederick Douglass, to our current age of the selfie?

Montague: There are many examples of a desire as a collector to seek out various modes of representation, and one of the most interesting ways is through self-portraiture. I was looking for images of myself, reflections of my own identity in different images. That boy with the British flag in Vanley Burke's iconic image reminded me of myself as a boy on a bicycle in Windsor, waving Canadian and Jamaican flags (page 15). That image has become burned in my brain. I believe that connection comes from the impulse to show the many ways of being and becoming.

And then there's also wanting to present the simplicity and beauty of daily life: Black hairstyles, people at a party on the beach, leisure time, etc. I grew up seeing images of Black folks historically in struggle or in some form of oppression. I was hell-bent on ensuring that my collection was not going to perpetuate that view, but rather show the beauty and power of Black life. Photography was an accessible way

into art-collecting. I caught the medium at a moment of intense production around storytelling from particular artists that I was interested in. It was the moment of Lorna Simpson, Dawoud Bey, Carrie Mae Weems, and June Clark, among others. It was a moment of expansion. I caught the wave and now, I see a thread through that work right to new Black artists like Arielle Bobb-Willis, Kennedi Carter, and Texas Isaiah.

Ikiriko: We are in an age that has been called a "Black Renaissance," as global attention has been turned to artists of African descent. As a collector, what futures do you see for Black artists and the contemporary art market?

Montague: I'm thrilled that many more Black artists have been given opportunities to produce work. It was historically a small pool, who faced great trouble getting their work noticed by the art world—hence the reason to start Wedge Curatorial Projects with the mandate to support and promote Black artists.

The art market is reflective of our current age. There's value being assigned to artists that I've personally championed for more than two decades, and it's a wonderful thing to see. I've known LaToya Ruby Frazier for over a decade and bought her work early on, and I am so thrilled to see that her work is being celebrated. There's also a sense of thinking, What took you all so long? Much of the thrill is seeing work being celebrated that hadn't been on the radar of the mainstream before, and that is the continued mission. There are so many more stories to be told, and so many more ways of thinking about being Black and experiences that we, as Black folks, have a unique language and way of describing. And there is a new urgency for me now, because my partner, Sarah, and I have two young sons who deserve to experience contemporary art that speaks to their own identity. So I am committed to the change that is necessary in museums, galleries, and collections.

I'm keeping a close watch, because I know how quickly things can turn. My position has always been to stay with the program, so that when the art world moves on to the next big thing, we will continue to make progress. It's not a win if we don't fully break the door down and have significant and lasting institutional change. The institutions are collecting these works, which is ultimately what you want beyond private collectors, so a larger audience will see the work over a greater amount of time. But what is also critical is that the work is seen as fundamental to the history of contemporary art. That it becomes part of the canon and recognized as something that should have always been a vital part of the story. I'm optimistic—as I see more Black people, people in our own community, beginning to collect work by Black artists.

Author Biographies

Dr. Isolde Brielmaier is assistant professor in the Department of Photography and Imaging at New York University's Tisch School of the Arts, where she focuses on contemporary art, global visual culture, and media and immersive technology as platforms to rethink storytelling and the politics of representation. She is also inaugural curator-at-large at the International Center of Photography, and previously oversaw the arts and cultural programming at the Oculus at Westfield World Trade Center, New York. Brielmaier has written extensively on contemporary art and culture and is editor of the book *Culture as Catalyst* (2020). She has served as curator at several institutions, including the Solomon R. Guggenheim Museum and the Bronx Museum of the Arts. She has received fellowships from the Andrew W. Mellon and Ford Foundations, as well as the Social Science Research Council. She serves on the board of trustees of the New Museum, as well as of the Women's Prison Association, New York. She holds a PhD from Columbia University and lives in Brooklyn.

Dr. Sandrine Colard is assistant professor of African art history at Rutgers University–Newark, New Jersey, as well as an independent curator, researcher, and writer. Colard holds a PhD from Columbia University, New York, and is a specialist in modern and contemporary African art and photography. Her curatorial projects include *The Way She Looks: A History of Female Gazes in African Portraiture* at the Ryerson Image Centre, Toronto (2019). She was artistic director of the 2019 Lubumbashi Biennale, Democratic Republic of the Congo. An international lecturer and author of multiple publications, Colard's research has been supported by numerous fellowships, including the Musée du quai Branly, Paris; Ford Foundation; and Getty/ACLS Postdoctoral Fellowship in the History of Art.

Teju Cole is a photographer, novelist, essayist, and curator. His photobook *Blind Spot* (2017) was shortlisted for the 2017 Paris Photo–Aperture Foundation Photo-Book Awards. His other books include the novel *Open City* (2011), winner of the 2012 PEN/Hemingway Award, and the photobooks *Fernweh* (2020) and *Golden Apple of the Sun* (2021). Cole's photography has been the subject of numerous solo exhibitions. He has been a visiting critic at the Yale School of Art, New Haven, Connecticut; and he was photography critic for the *New York Times Magazine* until 2019. He is currently a professor in the English department at Harvard University, Cambridge, Massachusetts.

Letticia Cosbert Miller is a Toronto-based writer, curator, and researcher. She holds both a BA and an MA in classics, and her work as a writer is often in dialogue with historical, mythological, or philosophical tropes from the Western classical tradition—interrogating its cultural proliferation. Cosbert Miller's writing and editorial work has been featured in the *Toronto Star*, *Canadian Art*, *BlackFlash Magazine*, and elsewhere.

Dr. Julie Crooks is curator, Arts of Global Africa and the Diaspora at the Art Gallery of Ontario. She holds a PhD from the Department of History of Art and Archaeology at the School of Oriental and African Studies, University of London. Since joining the AGO in 2017, Crooks has curated a number of exhibitions, including *Free Black North* (2017), *Mickalene Thomas: Femmes Noires* (2018), and presentations from the collection such as *Photography, 1920s–1940s: Women in Focus* (2019–20). Crooks has actively participated in bringing works by Black artists into the AGO's collection, including Dawoud Bey, Paul Kodjo, Malick Sidibé, Ming Smith, David Zapparoli, and most notably, the Montgomery Collection of Caribbean Photographs.

Daisy Desrosiers is director and chief curator of Gund Gallery at Kenyon College, Gambier, Ohio. She was previously inaugural director of artist programs at the Lunder Institute for American Art, an incubator for research and artistic practice in the Colby College Museum of Art, Waterville, Maine. In May 2020, Desrosiers was guest critic for the *Brooklyn Rail*, where she invited an array of artists, collaborators, and thinkers to reflect on translation and mistranslation as creative processes. In 2018, she was the inaugural Nicholas Fox Weber Curatorial Fellow at the Glucksman, University College Cork, Ireland. Desrosiers is trained as an interdisciplinary art historian and curator. Through the lens of cultural studies and postcolonial theories, her recent research is concerned with the role of commodities in contemporary practices, such as the use of sugar.

Liz Ikiriko is a Tkaronto/Toronto-based, Nigerian Canadian artist and curator. She is assistant curator at the Art Gallery of York University, Toronto, and cocurator of the 13th Rencontres de Bamako/African Biennale of Photography, Mali (2021). Her most recent curatorial projects include *Is Love a Synonym for Abolition?* at Gallery 44, Toronto (2021); *__a lineage of transgression__* at ArtSpace Peterborough, Canada (2020); and *The Break, The Wake, The Hold, The Breath* at Circuit Gallery, Prefix Institute of Contemporary Art, Toronto (2019). Her writing has appeared in *Public Journal*, *MICE Magazine*, *C Magazine*, *BlackFlash Magazine*, and *Akimbo*. Ikiriko holds an MFA in criticism and curatorial practice from Ontario College of Art and Design University, Toronto.

O'Neil Lawrence is an artist, curator, researcher, and writer. He has worked at the National Gallery of Jamaica, Kingston, in various capacities since 2008 and is currently its chief curator. Lawrence's research interests include race, gender, and sexuality in Caribbean and African diasporic art and visual culture; memory, identity, and hidden archives; and photography as a medium and a social vehicle. Lawrence's most recent article, "Through Archie Lindo's Lens: Uncovering the Queer Subtext in Nationalist Jamaican Art," appeared in the journal *Small Axe* in November 2020. Lawrence also serves on the advisory council of the Caribbean Art Initiative.

Dr. Kenneth Montague started the Wedge Collection in 1997 to acquire and exhibit art that explores Black identity. In addition to the Wedge Collection, Montague founded Wedge Curatorial Projects, a nonprofit arts organization that helps to support emerging Black artists. A Toronto-based art collector, Montague is the owner of Word of Mouth Dentistry and has been a member of the Art Gallery of Ontario's board of trustees since 2015. He has served on the African acquisitions committee at Tate Modern, London, and is an advisor to the Department of Arts of Global Africa and the Diaspora at the Art Gallery of Ontario.

Dr. Ugochukwu-Smooth C. Nzewi is an artist and the Steven and Lisa Tananbaum Curator in the Department of Painting and Sculpture at the Museum of Modern Art, New York. Nzewi has curated major international exhibitions, including the Dakar Biennale, Senegal, in 2014; and he served on the curatorial team for the Shanghai Biennale in 2016–17. As an artist, Nzewi has exhibited internationally and is represented in public and private collections, including those of the National Museum of African Art, Washington, DC; and Newark Museum of Art, New Jersey.

Dr. Mark Sealy is interested in the relationships between photography and social change, identity politics, race, and human rights. He has been director of Autograph ABP (Association of Black Photographers), UK, since 1991, and has produced numerous artist publications, curated exhibitions, and commissioned photographers and filmmakers worldwide. He curated the exhibition *From Here to Eternity: Sunil Gupta. A Retrospective* at the Photographers' Gallery, London (2020), and Ryerson Image Centre, Toronto (2022); and he is author of the book *Decolonising the Camera: Photography in Racial Time* (2019). Sealy holds a PhD from Durham University, England, and currently serves as Principal Research Fellow Decolonising Photography at University of the Arts London.

Teka Selman is a cultural advisor based in Durham, North Carolina, where she heads Selman Contemporary, an art advisory firm that focuses on building impactful and intentional art collections. In her roles as gallerist, curator, and consultant, she has collaborated on exhibitions and projects with artists, including Mark Bradford, William Cordova, Heather Hart, Barkley L. Hendricks, Wangechi Mutu, and Stacy Lynn Waddell. She holds a BA in art history and anthropology from the University of Michigan, Ann Arbor, and an MA in visual cultures from Goldsmiths, University of London.

Dr. Zoé Whitley is director of Chisenhale Gallery, London. She has curated and cocurated several exhibitions, including *Elijah Pierce's America* at the Barnes Foundation, Philadelphia; the British Pavilion at the 2019 Venice Biennale; and the award-winning international touring exhibition *Soul of a Nation: Art in the Age of Black Power*. Whitley writes widely on contemporary artists; and she is a trustee of both Creative Access, London, and the University of Arts London's Decolonising Arts Institute. Whitley's prior roles include senior curator at Hayward Gallery, curator of international art at Tate Modern, and curator of contemporary programs at the Victoria and Albert Museum, London.

Dr. Deborah Willis is university professor and chair of the Department of Photography and Imaging at the Tisch School of the Arts, New York University. She is recipient of MacArthur and Guggenheim Fellowships, and author of the books *The Black Civil War Soldier: A Visual History of Conflict and Citizenship* (2021) and *Posing Beauty: African American Images from the 1890s to the Present* (2009), among others. Willis has curated exhibitions including *Let Your Motto Be Resistance: African American Portraits* at the International Center of Photography, New York; *Out [o] Fashion Photography: Embracing Beauty* at the Henry Art Gallery, University of Washington, Seattle; and *Reframing Beauty: Intimate Visions* at Indiana University, Bloomington.

Acknowledgments

This book is dedicated to my mother Ellen Montague, who showered me with love. And my father Spurgeon Montague, who lived by his motto, "Lift as we rise," and passed it on.

I would like to thank the following individuals for their support in the creation of this book:

My wonderfully supportive partner Sarah, and our sons Eli and Theo. My sister Lori and brother Christopher. I love my family.

Drs. Frederick and Liza Murrell, Dawoud Bey, and John Ellis: your support made this book possible.

The Wedge Collection team: Maria Kanellopoulos, Emilie Croning, and Liz Ikiriko for your invaluable contributions. And your care.

The Aperture team: Denise Wolff for everything. Lanah Swindle for coordinating everything. Special thanks to Elena Goukassian and Susan Ciccotti, Andrea Chlad and Minjee Cho. Also, Emily Grillo and Kodie-Ann Walcott, Annette Booth, Giada De Agostinis, Richard Gregg, and Emily Stewart. And to Chris Boot for your belief.

Designer extraordinaire: Jeanette Abbink of Rational Beauty.

Contributing writers: Isolde Brielmaier, Sandrine Colard, Letticia Cosbert Miller, Julie Crooks, Daisy Desrosiers, O'Neil Lawrence, Ugochukwu-Smooth C. Nzewi, Teka Selman, Zoé Whitley, and Deborah Willis. Special thanks to Mark Sealy, Teju Cole, and Liz Ikiriko. One Love.

Thank you to those whose contributions have helped give Wedge its shape: Justin Aranha, Magdalyn Asimakis, Paul Bain, Stephen Bulger, Warren Crichlow, Pamela Edmonds, Silvia Forni, Thelma Golden, Owen Gordon, Sophie Hackett, Darcy Killeen, Marie Lortie, Nadir and Shabin Mohamed, Robert Osbourne, David Peterson, Bonnie Rubenstein, Melanie Scherenzel-Cherry, Trevor Schoonmaker, Tré Seals, Camilla Singh, Zeb Smith, Maia Sutnik, Del Terrelonge, Lauren Wickware.

Dearly departed, never forgotten: Stuart Hall, Okwui Enwezor, Bisi Silva, and Barkley L. Hendricks.

And, of course, my love and respect to all of the artists: you are the source; you are the future.

Peace,
Kenneth Montague
The Wedge Collection

As We Rise:
Photography from the Black Atlantic
Selections from the Wedge Collection

Preface by Teju Cole
Introduction by Mark Sealy
Interview by Liz Ikiriko
With texts by Isolde Brielmaier, Sandrine Colard, Letticia Cosbert Miller, Julie Crooks, Daisy Desrosiers, Liz Ikiriko, O'Neil Lawrence, Kenneth Montague, Ugochukwu-Smooth C. Nzewi, Teka Selman, Zoé Whitley, Deborah Willis

Front cover (clockwise from top, spiraling to the center): L. Kasimu Harris, *The Road Ahead (Morrisa and Malcolm Jenkins)*, 2013 (pages 76–77); Jamel Shabazz, *Rude Boy, Brooklyn, New York*, 1982 (page 18); Ruddy Roye, *The Question*, 2010, from the series *Nigga Beach* (page 45); Rashid Johnson, *The Reader*, 2008 (page 161); Dawit L. Petros, *The Porch*, 2003 (page 17); James Barnor, *Drum Cover Girl Erlin Ibreck, Kilburn, London*, 1966 (page 117); Texas Isaiah, *My Name Is My Name I*, 2016 (page 85); Jamel Shabazz, *Flying High, Brooklyn, New York*, 1982 (pages 22–23); Vanley Burke, *Boy with Flag, Winford, in Handsworth Park*, 1970 (page 15); Liz Johnson Artur, *Burgess Park*, 2010 (page 151)

Back cover (clockwise from top, spiraling to the center): Barkley L. Hendricks, *Untitled*, ca. 2000 (page 56); Lakin Ogunbanwo, *Untitled (Purple Hat)*, 2013 (page 106); Courtney D. Garvin, *Bre & Josh*, 2015 (pages 166–67); Michèle Pearson Clarke, *Melisse Sunflowers, July 30*, 2018 (page 41); Zun Lee, *Jebron Felder and his son Jae'shaun at home. Harlem, New York, September 2011* (page 74); William Cordova, *Badussy (or Machu Picchu After Dark)*, 2003–9 (page 122); Nontsikelelo Veleko, *Vuyelwa*, 2003–7 (page 120); Athi-Patra Ruga, *The Naivety of Beiruth 1*, 2007 (pages 154–55); Dawoud Bey, *A Boy in Front of the Loew's 125th Street Movie Theatre, Harlem*, 1976 (page 119); Teju Cole, *Brazzaville, February 2013*, 2013/2018 (pages 128–29)

Editor: Denise Wolff
Editorial Assistant: Lanah Swindle
Designer: Jeanette Abbink
Production Director: Minjee Cho
Production Manager: Andrea Chlad
Senior Text Editor: Susan Ciccotti
Copy Editor: Elena Goukassian
Proofreader: Claire Voon

Additional staff of the Aperture book program includes: Chris Boot, Executive Director; Lesley A. Martin, Creative Director; Taia Kwinter, Publishing Manager; Emily Patten, Publishing Assistant; Samantha Marlow, Associate Editor; Brian Berding, Designer; Kellie McLaughlin, Chief Sales and Marketing Officer; Richard Gregg, Sales Director, Books

An exhibition accompanying this book will be on view at the Art Museum, University of Toronto, in Fall 2022, and at the Polygon Gallery, North Vancouver, in Spring 2023. Curated by Sarah Robayo Sheridan and Justin Ramsey.

Special thanks:
As We Rise was made possible, in part, with generous support from Drs. Frederick and Liza Murrell, and Dawoud Bey. Additional support was provided by John E. Ellis, MD.

Aperture's programs are made possible, in part, by the New York State Council on the Arts with the support of Governor Andrew M. Cuomo and the New York State Legislature.

As We Rise has been typeset using three typefaces. Display type on the title page and elsewhere is called Martin, created by Vocal Type. It was inspired by the signage carried during the 1968 Memphis Sanitation Workers Strike and named for Dr. Martin Luther King Jr. Body text is set in GT Super, created by Grilli Type. Captions are set in Caslon Doric, created by Commercial Classics.

First edition, 2021
Printed in China
10 9 8 7 6 5 4 3 2 1

Library of Congress Cataloging-in-Publication Data available upon request.
ISBN 978-1-59711-510-0

To order Aperture books, or inquire about gift or group orders, contact:
+1 212.946.7154
orders@aperture.org

For information about Aperture trade distribution worldwide, visit:
aperture.org/distribution

aperture

Aperture Foundation
548 West 28th Street, 4th Floor
New York, NY 10001
aperture.org

Aperture, a not-for-profit foundation, connects the photo community and its audiences with the most inspiring work, the sharpest ideas, and with each other—in print, in person, and online.